IMAGES
of America

NEW PORT RICHEY

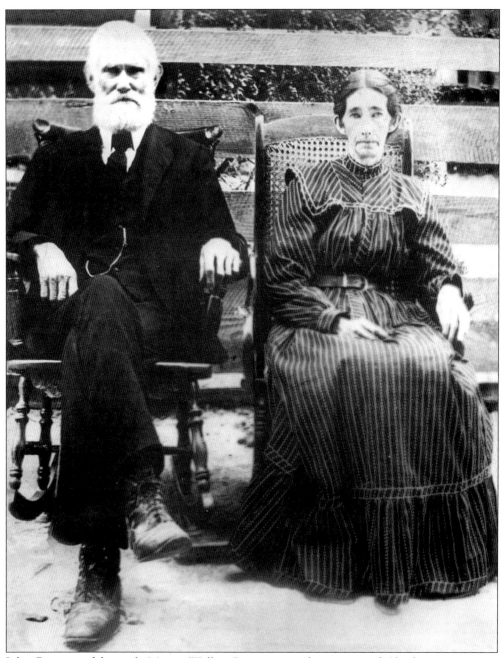

John Rogers and his wife Mittye Walker Rogers were the parents of Charlie Mae Rogers. Charlie Mae Rogers married Porter Lamar Pierce and came to the New Port Richey area with their children in 1913 from Fulton, Mississippi. Mr. Pierce was a school teacher and devoted his life to education. In 1926, an elementary school constructed on Main Street was named Pierce School in his honor. One of their children, Mittye Pierce Locke, who also dedicated her life to education, was the long-time principal of Elfers Elementary School, which was renamed in her honor.

IMAGES
of America

NEW PORT RICHEY

Adam J. Carozza

ARCADIA

Copyright © 2004 by Adam J. Carozza
ISBN 0-7385-1648-1

Published by Arcadia Publishing
Charleston SC, Chicago IL, Portsmouth NH, San Francisco CA

Printed in Great Britain

Library of Congress Catalog Card Number: 2004102285

For all general information contact Arcadia Publishing at:
Telephone 843-853-2070
Fax 843-853-0044
E-mail sales@arcadiapublishing.com
For customer service and orders:
Toll-Free 1-888-313-2665

Visit us on the internet at http://www.arcadiapublishing.com

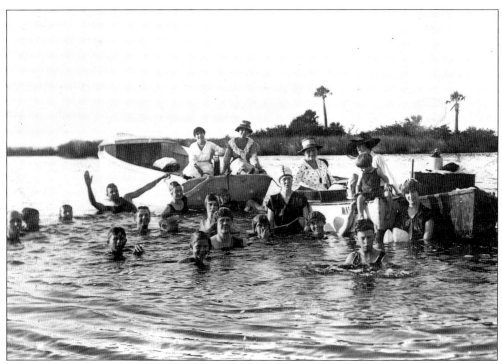

Some early residents show their Northern friends that swimming in winter is possible in Florida. There are many favorite spots for swimming in the area. The Pithlachascotee River flows directly through the town of New Port Richey and empties into the Gulf of Mexico. Inlets and bayous of the Gulf touch the town limits.

CONTENTS

ACKNOWLEDGMENTS

I owe deep gratitude to so many people for their help with this project. I wish to thank all the officers, directors, librarians, and members of the West Pasco Historical Society Museum and Library for allowing me use of their facility and priceless photographs from their archives.

I would also like to acknowledge the people who either contributed photographs or helped me in identifying them. Thanks to Jeff Miller (photograph archivist), Joseph Copeland, Mary Crockett, and Gene Scott. Encouragement and motivation to take on this project was provided by Jim Schnur, assistant university librarian special collections, as well as Prof. Gary Mormino and Prof. Ray Arsenault at the Florida Studies Program at the University of South Florida in St. Petersburg.

Thanks to my long time friend Jack Pacheco for his helpful assistance in dealing with my computer equipment. Special thanks to Bea Baum, librarian at the West Pasco Historical Research Library. This book would not have been possible without her wonderful assistance. Also, special thanks to my wife Linda and my daughters, Carol Marie and Linda Catherine, for their patience. This book is dedicated to all the families past, present, and future in New Port Richey and the West Pasco area.

INTRODUCTION

When even the memory of this people (the Calusas) is forgotten, the Great Spirit will give this land to another—a strange but noble people made up of every tongue yet speaking the same language from the East and the West, from the North and the South they shall come, and they shall possess the land on the banks of this river of beauty and enchantment, and they shall dwell here in numbers greater than the number of the palm leaves that rustle in the evening breezes, the river a winding length even from the Trident Palm to the broken altar of Toya by the sea. And they shall remain here always in peace and happiness.

–Mucoshee, last Calusa warrior chief

In 1883, Aaron McLaughlin Richey came from St. Joseph, Missouri, to visit an old friend who lived in Brooksville, Florida. That friend, James Washington Clark, was one of the early pioneers of the area. He owned land on the Gulf Coast where he had lived before moving to Brooksville. The two friends decided to travel to the coast, where fishing was excellent and game plentiful. Upon arriving and setting up camp on the Clark holdings, Mr. Richey decided this was the place for him. He thought that the sunshine and warm climate would be just the thing for his ailing wife and an ideal spot to rear his children. Richey negotiated with a man by the name of Felix Sowers, who had an orange grove and some cleared land, to buy the point of land at the mouth of the river. It was here that he established his home, in a small weather-beaten house overlooking the Gulf of Mexico. Richey soon found that the best and fastest method of transportation to ports along the Gulf was by water. With an eye to commerce and transportation, he soon had a schooner built in Cedar Key. When the schooner was delivered, Richey found it necessary to have it registered, giving it the name of its homeport. There being no specific name for the place where it would be moored, he simply called it Port Richey, a name that would remain for one of the most beautiful places on the coast. This was the beginning of not only Port Richey, but the newer and larger city of New Port Richey, which was settled shortly after. Later, New Port Richey would incorporate in 1924, one year before Port Richey.

Before the Civil War, orange groves and cattle ranches were abundant in Pasco County. Most of the cattle of this area were exported to Cuba until the Civil War, when they were needed to supply the Confederate Army. Pasco County also developed into a major citrus-producing center. In addition, a nearby salt works at Salt Springs supplied the substance to the

local residents, as well as the Confederate Army. It was a valuable commodity used to preserve meats before the advent of refrigeration.

At the turn of the 20th century, New Port Richey was a planned community designed for people of means. The city planners attempted to attract tourists with the hope of turning them into residents. Hotels were built and advertisements were posted as far north as New York. Fishing was one of the main attractions in the area. In time, golf courses and theaters would also be built. Banks, drug stores, and various shops opened along Main Street and the Boulevard.

The Chasco Fiesta remains one of the largest attractions to lure people to downtown New Port Richey. Started as a small event in 1922, it has now become a huge fund-raiser for many philanthropic causes. The annual festivities were derived from a myth about a Spanish boy and girl captured by the Calusa Indians. After acceptance into the tribe, they were later wed as Queen Chasco and King Pithla. Legend has it that on New Year's Day in 1922, Gerben DeVries, New Port Richey's first postmaster, discovered a parchment in an old clay cylinder found on the banks of the Pithlachascotee River. The text, in old Castilian Spanish, was written by a priest named Padre Luis. Mr. DeVries later wrote a narrative based on that parchment's message entitled *Chasco, Queen of the Calusas*, which is widely recognized as the basis of the legend of Chasco.

In the 1920s and 1930s, New Port Richey was considered a boom town. Some notable people in the early days of theater came to New Port Richey and bought land. Jasmine Point, an exclusive subdivision of homes, was built in 1924. The Palms Theater, designed to show silent movies, opened in 1921, and the Meighan Theater was built on the Boulevard at Nebraska Avenue in 1925. The theater was named for the "Silent Screen" star Thomas Meighan. In the spring of 1930, Thomas Meighan was present at the theater to push the button that would bring sound to the screen for local residents with the coming of the "talkies." New Port Richey was slated to become a new movie center. However, it never reached completion. The country's economy slowed after the stock market crash, and growth capital was hard to accumulate. The untimely death of Thomas Meighan in 1936 finally brought an end to the fabulous dream of so many, and the "Hollywood of the South" was not to be.

New Port Richey, Florida, like many cities between Jacksonville and Tampa, can thank Henry Plant's 1885 railroad for much of the phenomenal growth of the region. Thirty-five miles northwest of Tampa, in West Pasco County, New Port Richey eventually hosted its own railway connection right through downtown. City planners constructed the community in a grid, naming north-south streets after presidents and east-west streets after states. The arrival of the U.S. Post Office in 1915 confirmed this city's importance and put New Port Richey on the map. In 1924, New Port Richey incorporated, one year before Port Richey. Hotels, banks, and businesses sprang up in the downtown area to serve those who came in search of a better life. Fishing on the Pithlachascotee River and in the Gulf of Mexico attracted many visitors, as did the construction of golf courses. Businessmen, both then and now, have been able to recognize the importance of an area that caught the attention and the hearts of people from all states north of Florida.

Many people would come to New Port Richey and the West Pasco area from parts north for various reasons, including their health and the warmth of the sun. It was promoted as a place for fishing, hunting, golfing, leisure, and retirement. Early advertisements claimed it was a place with an abundance of fish, oysters, and game. It was a place to have good neighbors, schools, churches, and a wholesome moral atmosphere. New Port Richey also provided its citizens with the freedom, comfort, and pleasures of a small town within easy access of big cities and fashionable resorts—a claim still made today. In New Port Richey's early beginnings, concentrations of people sharing a similar life-style formed an enclave. There is a strong tie between that life-style and the geographic space these residents occupy. New Port Richey is recognized as the "Gateway to Tropical Florida," and with the stunning Pithlachascotee River winding its way through town on its journey to the Gulf of Mexico, it has remained the place for people to settle.

One
EARLY SETTLERS

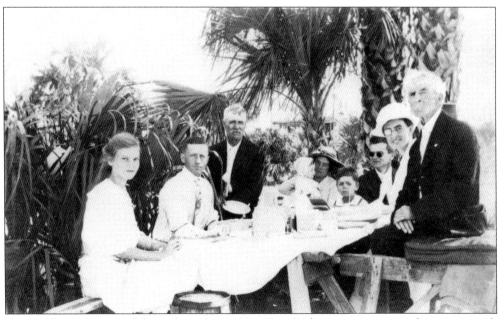

Pictured here are some of the early settlers in New Port Richey enjoying an outdoor picnic with family and friends. At the far left is Amorita DeVries, daughter of the first postmaster, Gerben DeVries. He was the author of *Chasco, Queen of the Calusas*, which is recognized as the basis of the legend of Chasco.

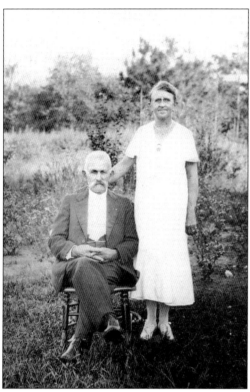

Fred C. Rowan (1856–1946) moved to New Port Richey with his wife Emma M. (1860–1952) in 1915, from Grand Rapids, Michigan. Mr. Rowan was a contractor and builder and constructed many homes in the area. Rowan Road is named in his honor.

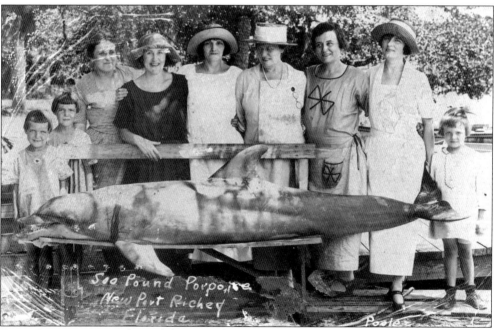

Emma Rowan was president of the civic club. These ladies pose with a 200-pound porpoise. Pictured from left to right are the following: Anna Casey, Mary Jane Casey, unidentified, Mrs. Lillian Clark, Mrs. Margie Casey, two unidentified persons, Mrs. George Sims, and Henrietta Poole.

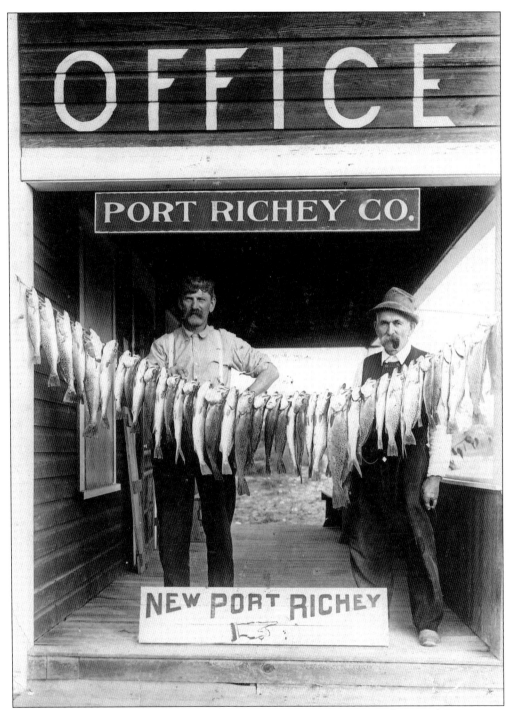

Mike Broersma and Fred Rowan are pictured on the porch of the Port Richey Land Company as they show the fish they caught. In the Pithlachascotee River, trout, red fish, sheepshead, snapper, mullet, and black bass were abundant. In nearby freshwater lakes, brim and big-mouth bass were plentiful. The Gulf of Mexico yielded Spanish mackerel, blue fish, kingfish, red snapper, grouper, amber jack, and tarpon.

11

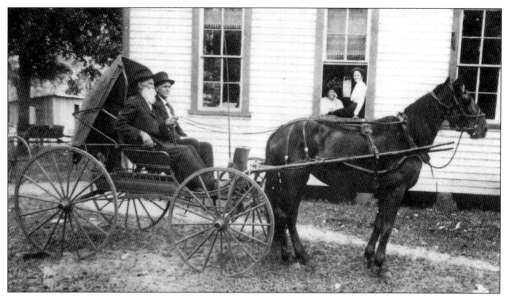

Two gentlemen with a horse and buggy pass by as two ladies watch from the window. After the automobile arrived, this was still a reliable mode of transportation, especially before New Port Richey had paved roads.

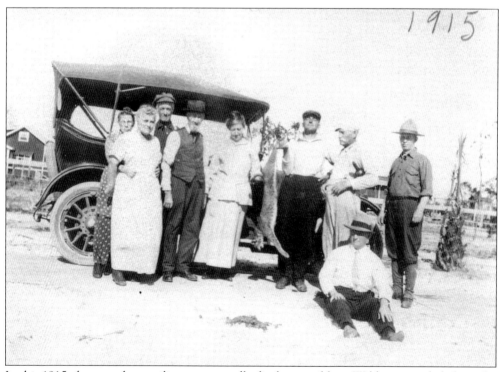

In this 1915 photograph, a smiling man proudly displays a wildcat. Wildcats prowled along the rivers and dense hammocks in and around the New Port Richey area.

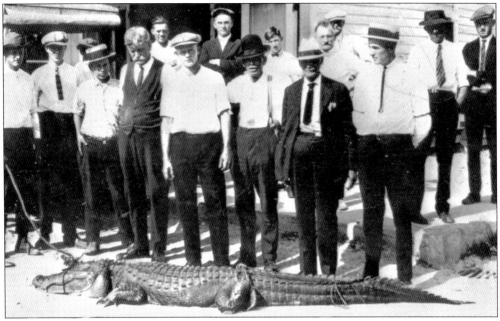

Pictured here are some early settlers standing in front of the drug store on the Boulevard watching over a large alligator. When alligators were not in the Pithlachascotee River or sunning on its banks, they would come on land seeking shade under the palmettos.

Pictured here is the Draft family. Rollo Draft (1883–1963) came to the area with his wife Alice (1889–1986) in 1914, from Grand Rapids, Michigan. The Drafts purchased a lot on the Circle (Circle Boulevard) around Mirror Lake, now known as Orange Lake, in the heart of New Port Richey. They also purchased 10 acres of land outside of town. Mr. Draft and B.H. Hermanson opened a dry goods store on North Boulevard, now Grand Boulevard, and Main Street.

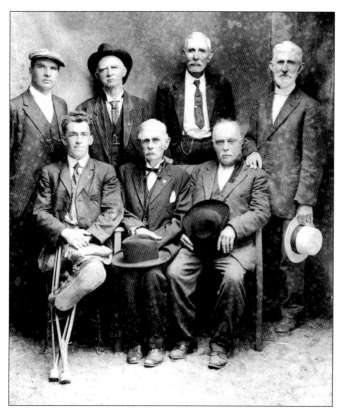

Pictured here, from left to right, are the following pioneer residents of the area: (front row) two unidentified persons and Samuel E. Hope; (back row) Sheldon Nicks, Henry Robert Nicks, Malcolm N. Hill, and unidentified.

Emma M. Rowan (1860–1952), one of the early pioneers, and her husband Fred settled here in 1915. She was president of the civic club and organized the New Port Richey chapter No. 117 Order of the Eastern Star in 1921.

H.E. Northrup stands by his automobile in front of the Palms Theater in 1921. The small wooden theater opened that year and showed silent movies.

An oxcart passes in front of the Pasco Building. Pictured in forefront, from left to right, are ? DeCubellis, Peter DeCubellis (driver), Lillian Clark (seated), Warren Kilborn, John ?, and Nellie Rothera. Peter DeCubellis (1875–1972) moved to New Port Richey with his wife Frances and their children from Montreal, Canada, in the late 1910s.

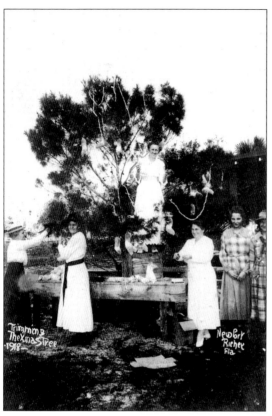

These ladies are pictured trimming a Christmas tree in the park in 1918. Pictured from left to right are the following: two unidentified women, Emma Rowan (in tree), ? Vickers, Gladys Leach, Amorita DeVries (daughter of the first postmaster, Gerben DeVries).

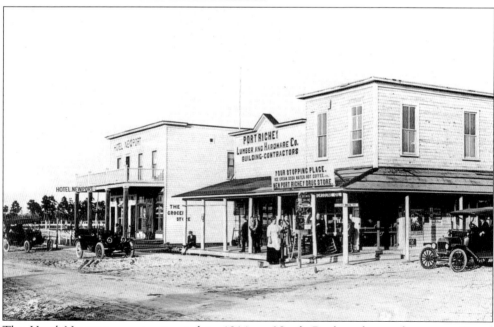

The Hotel Newport was constructed in 1914 on North Boulevard, now known as Grand Boulevard, in New Port Richey by A.J. Pauels and Mike Broersma. Sold in 1923 to Chauncey York, the hotel was renamed the Magnolia Inn.

In this 1928 photo, two unidentified ladies sit on the front porch. Although almost nonexistent today, the front porch was a way of life in those days. Sometimes spending many hours there, people would meet and greet their neighbors on the front porch. Since the invention of air conditioning, many people now spend their time indoors.

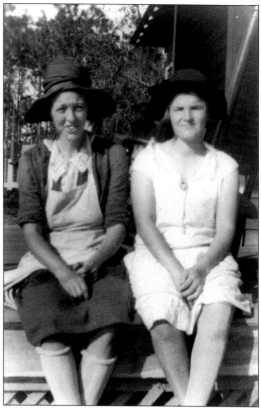

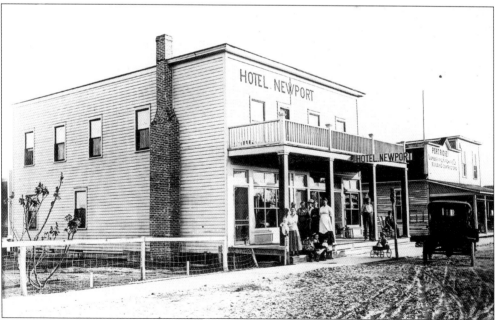

The Hotel Newport stands next door to the Port Richey Lumber and Hardware Company, c. 1916. On the far right under the Hotel Newport sign stands Mike Broersma. An automobile trying to navigate on the muddy Boulevard is also pictured.

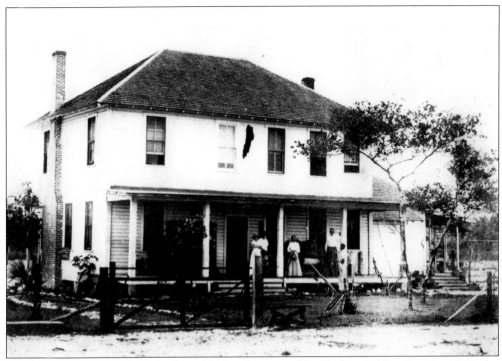

The popular Sass Hotel was built in 1913 and operated by Fred and Ollie Sass. In 1920, the Enchantment Inn Company bought the hotel and renamed it The Inn. The wooden structure was destroyed by fire in 1926.

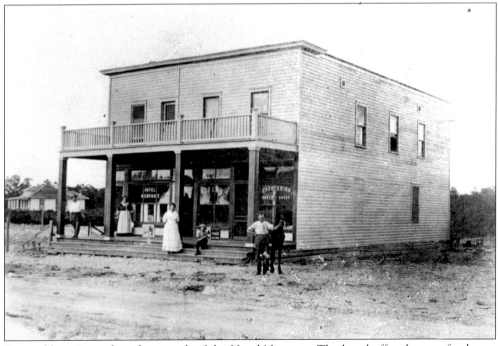

Pictured here is another photograph of the Hotel Newport. The hotel offered guests food on a self-serve system. Mr. Broersma is standing at far right.

Two

DOWNTOWN

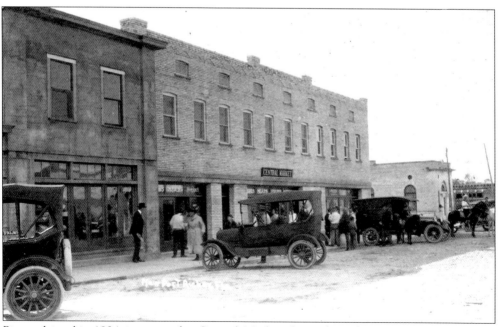

Pictured in this 1924 image is the Central Market, located in the Warner building. This building was on the south side of Main Street, east of the Boulevard.

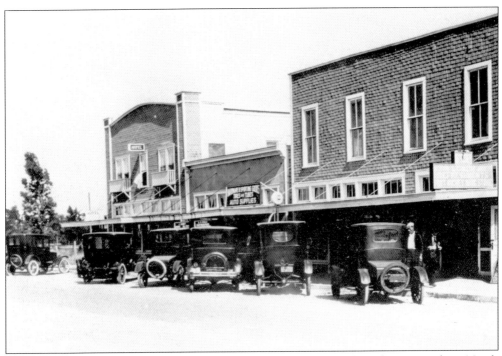

This picture of downtown, *c.* 1925, shows the Broersma Hotel and Draft Mercantile at North Boulevard and Main Street. The Port Richey Drug Store is at the far right.

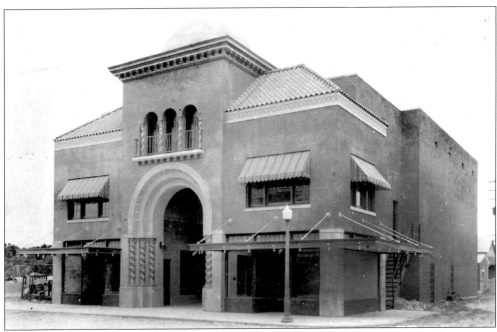

In 1925, a new theater was built on South Boulevard at Nebraska Avenue. The theater was named the Meighan Theater after the movie star Thomas Meighan. It seated 500 people and included a gallery. This theater initially showed silent movies to the accompaniment of a player piano. In the spring of 1930, sound tracks arrived to the screen with the coming of the "talkies."

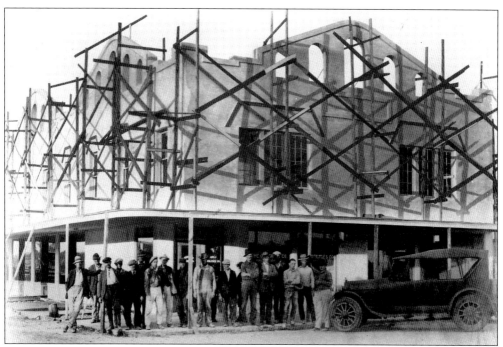

Constructed here in 1920, the Chasco Inn is believed to be the oldest commercial building in downtown New Port Richey. The inn contained a hotel, restaurant, bus station, and camera shop. In addition, the first post office was located here.

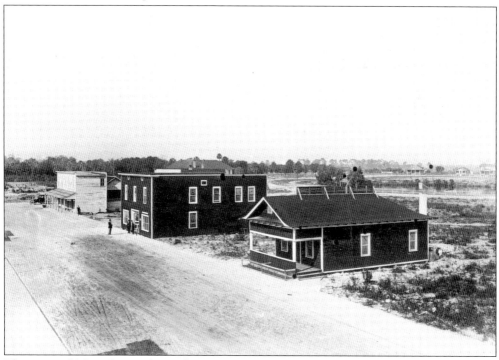

This view of Main Street shows the two-story, original wooden structure, called the Havens Building, erected in 1915. After renovation in 1920, this building would become the Chasco Inn.

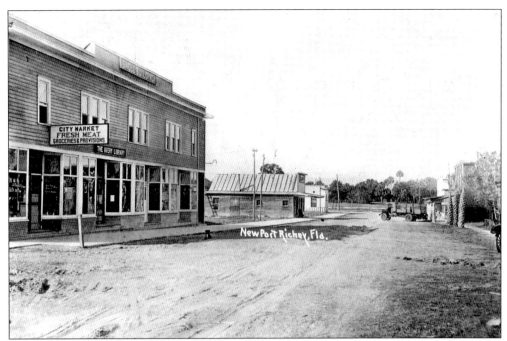

This view, looking west on Main Street from the old post office c. 1920s, shows the Snell Building with the Avery Library and the City Market. This site was the first home of the Avery Public Library, opened on April 10, 1920.

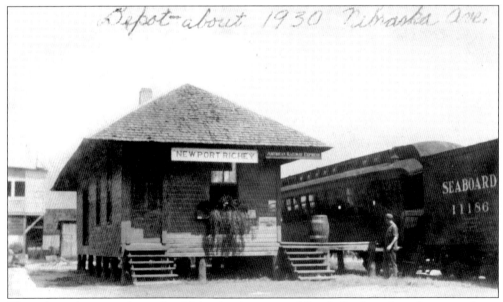

The railway depot was located at Nebraska Avenue and South Boulevard, as shown in this c. 1930 postcard. Once the train reached the New Port Richey terminal, located to the south of the city, it was forced to back up to the turn-a-round before it could proceed south to join the main line at Tarpon Springs.

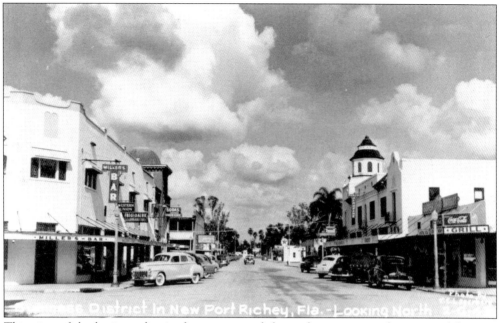

This view of the business district from a postcard shows the ornate cupola on top of the two-story Pasco Building. The facility was constructed in 1926 of masonry in a Spanish style. Directly across the street is the instantly recognizable, domed Meighan Theater. Also pictured is Miller's Bar.

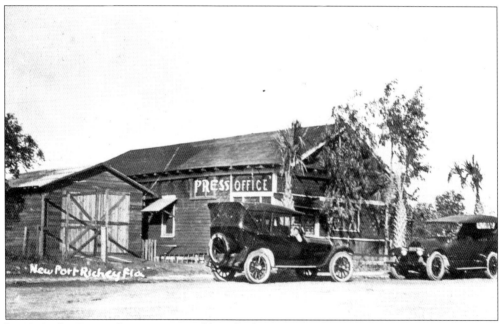

In 1918, the *Port Richey Press*, owned by Charles L. Fox and Son, was first published. It was renamed the *New Port Richey Press* in 1920. There were some earlier, short-lived newspapers such as the *Elfers West Pasco Record* and a small newsletter called the *New Port Richey Post*. Before that time, news was carried by word of mouth by local citizens, traveling salesmen, and ministers.

23

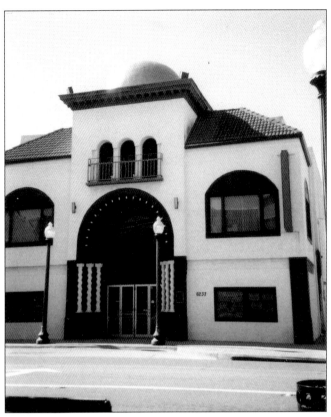

This modern photo of the Meighan Theater shows that some things do not change. It operated as a motion picture theater until 1968. Renamed the Richey Suncoast Theater, it now serves as a community playhouse.

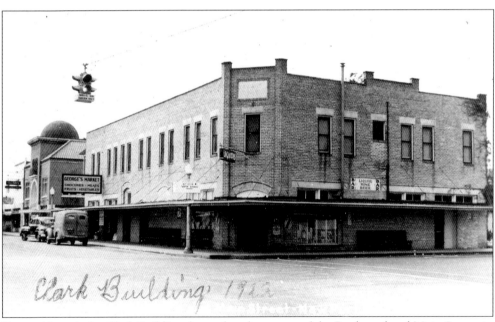

Pictured here is the Clark Building, located at the corner of the Boulevard and Main Street, in 1922. The *New Port Richey Press* was located in the Clark Building until 1927 when they moved to the Ravenhall Building on Missouri Avenue.

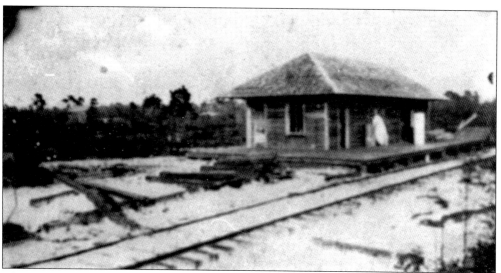

This *c.* 1915 photo shows the New Port Richey railway depot, located at South Boulevard and Nebraska Avenue. Railroad service to Elfers, just south of New Port Richey, was established first in the area as an extension service from Tarpon Springs in 1913 by the Tampa and Gulf Coast Railroad to accommodate the shipment of citrus. Then, during World War I, the track was extended to New Port Richey, pictured here. The New Port Richey Depot closed on April 25, 1943.

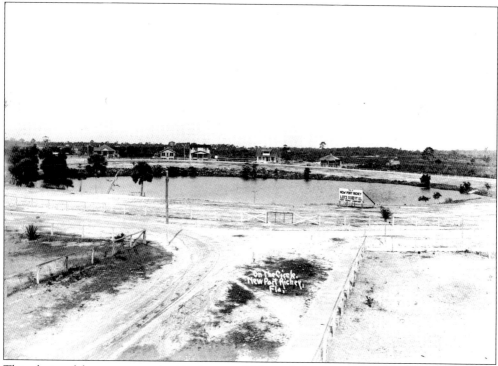

This photo of downtown on the Circle around Mirror Lake, now called Orange Lake, shows a billboard advertisement by the Port Richey Land Company selling lots for $100 and up.

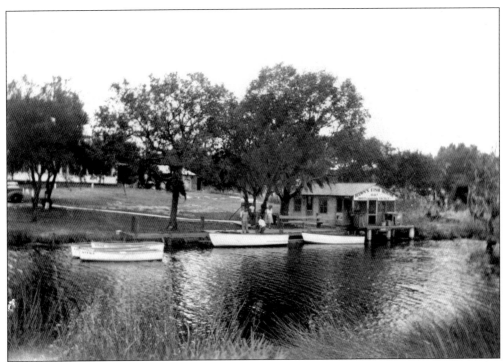

Pictured here is Hawn's Fish House on the Pithlachascotee River south of Main Street. This was a popular place to go for bait, tackle, and boats.

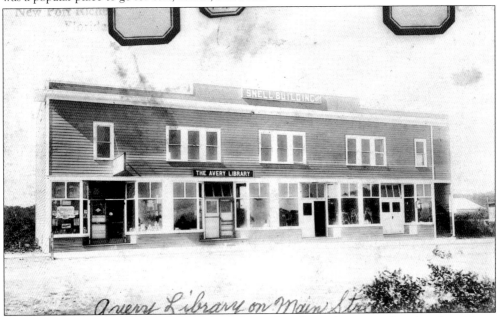

On April 10, 1920, the Avery Public Library opened its doors. Since this first day, the citizens of New Port Richey showed how necessary a library is to a community. Within the first few days, 37 members joined, and in the weeks that followed, many more books were received by donation. By May 6, the new library contained over 2,000 volumes and was proving to be an asset to the community.

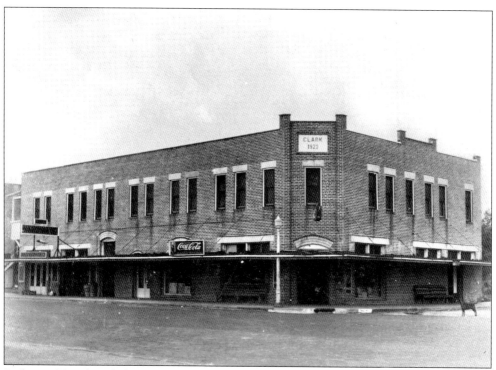

Built in 1922, the Clark Building is located at the southwest corner of Main Street and the Boulevard. The first floor held businesses, and the second floor was used as apartments. This site was also the early home of the *New Port Richey Press*.

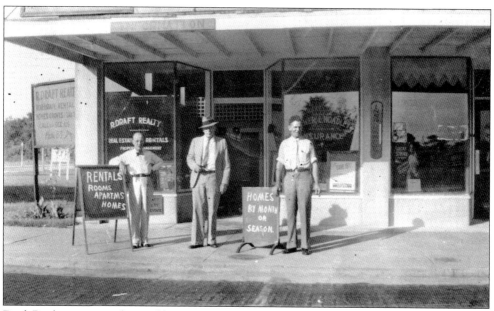

Draft Realty was one of several businesses operated by Rollo Draft. He first started a mercantile store and then opened a lumber yard. Then came this real estate office, and later he operated a checking bank, in connection with the First National Bank of Tarpon Springs.

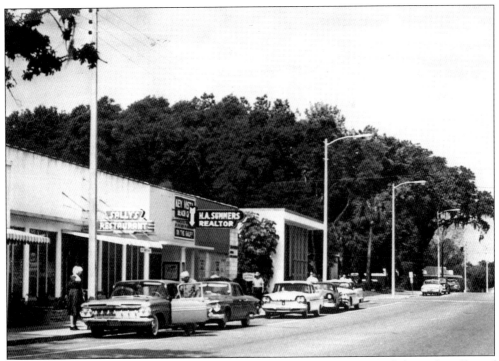

This photo of East Main Street looking west shows Sally's Restaurant and the realty office of H.A. Summers on the south side of the street.

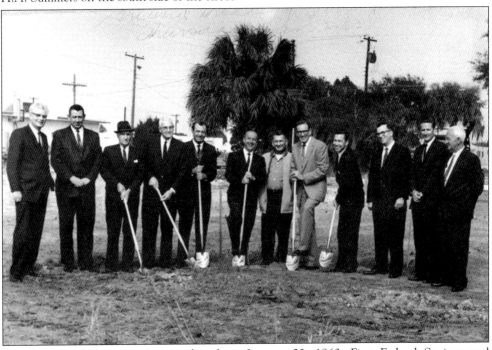

The growth of the area continued and on January 23, 1963, First Federal Savings and Loan Association of Tarpon Springs broke ground for a branch on West Main Street in New Port Richey.

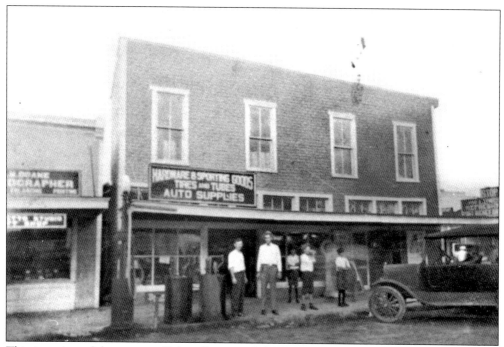

This is a view of the corner of Main Street and the Boulevard. In the 1920s, many businesses began to open on Main Street and on the Boulevard as the population increased in and around the New Port Richey area, from about 500 people to about 1,500 in a few short years.

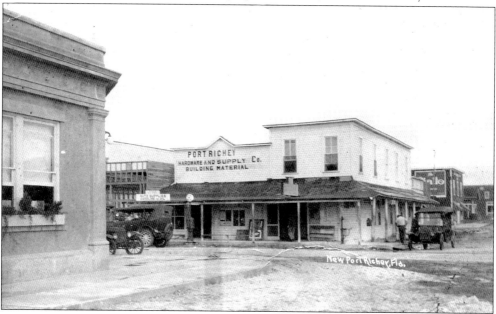

At one time, the Port Richey Land Company, pictured here c. 1922, owned 10,000 acres of land along the Pithlachascotee River. In 1911, P.L. Weeks, along with his brother J.S. Weeks Jr. and W.E. Guilford formed the Port Richey Company for the purpose of colonizing and developing land. George Sims (1876–1954) bought the Port Richey Land Company from P.L. Weeks and was a leading developer in the Florida boom years of the 1920s.

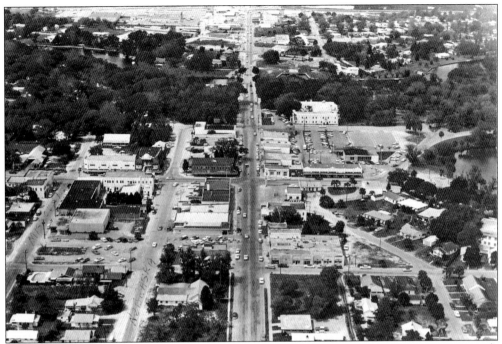

This aerial view of downtown, c. 1952, shows Orange Lake on the right and the Pithlachascotee River in the background.

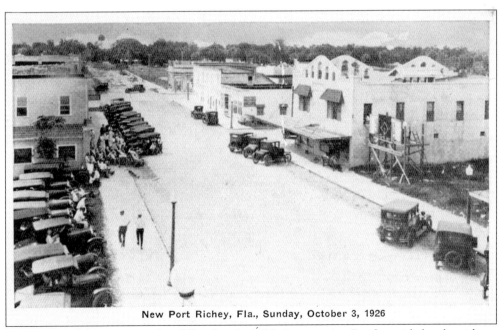

New Port Richey, Fla., Sunday, October 3, 1926

This photo of downtown is dated October 3, 1926. It is a quiet Sunday with local residents gathering to discuss matters of the day.

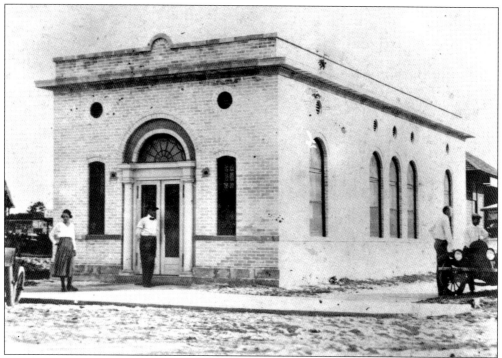

Land Office–Milbauer Building, the first brick building in New Port Richey, was erected in 1919. It is commonly called the Milbauer Building for its long-time owners, realtor Michael L. Milbauer and lawyer Richard J. Milbauer.

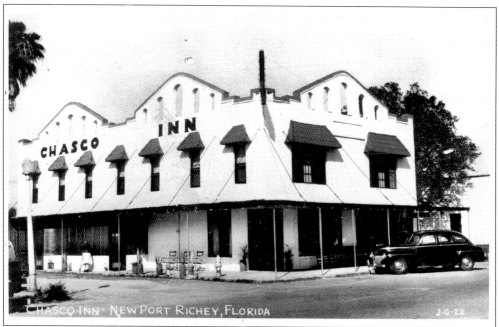

The Chasco Inn dates from the early 1920s and takes its name from Gerben DeVries's imaginary legend of Queen Chasco and King Pithla. The name Chasco is derived from the legend concocted in 1922 and is the basis for a charitable fund-raising festival.

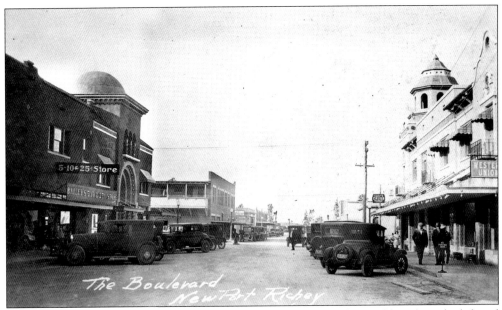

This is a view of the Boulevard looking north with the Meighan Theater (dome) on the left and the Pasco Building (cupola) on the right.

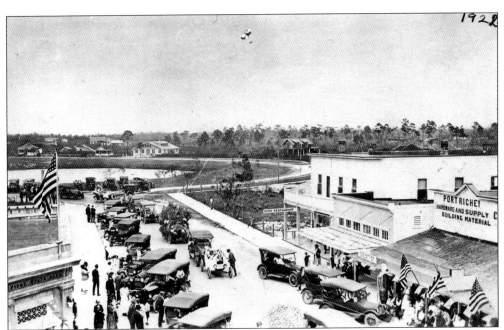

Pictured here is the first Chasco parade held in 1922, with decorated automobiles traveling south on the Boulevard from Orange Lake. The Chasco Fiesta has grown larger each year to include a street parade and boat parade and has been an annual event since that time.

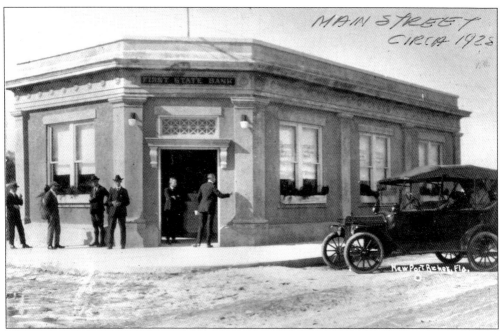

This c. 1925 view of the First State Bank Building at the corner of Main Street and the Boulevard shows William Barnett and George Sims in the doorway. This was the first bank organized in New Port Richey and it opened for business on October 15, 1921. One of the pioneer developers of New Port Richey, Dr. Elroy M. Avery, was the first president of the bank.

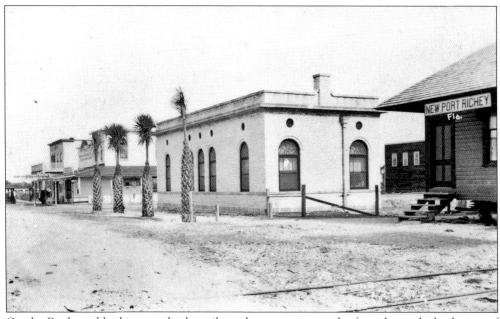

On the Boulevard looking north, the railway depot appears on the far right, and a back view of the Milbauer building can be seen left of the depot, c. 1920.

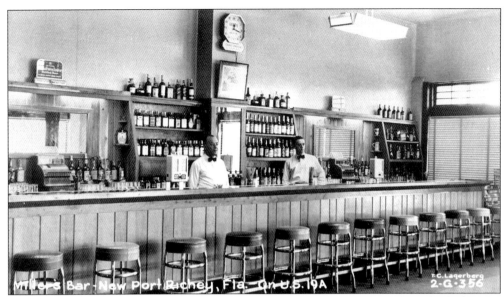

Miller's Bar is located at the southwest corner of Main Street and South Boulevard. The bar was a popular spot for residents to gather and catch up on the local news and a place for clubs to hold their meetings.

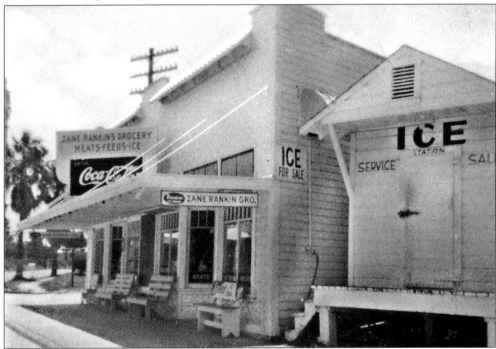

This 1960 photograph shows Zane Rankin's Grocery, which was located across the street from Gulf High School, now known as Schwettman Education Center, at South Boulevard and Gulf Drive. Zane arrived in New Port Richey on August 17, 1923 when he was 17 years old with his parents. After graduation from Gulf High School in 1927, Zane worked at several grocery stores in town and in 1941 inherited this store from his former employer, Charles Thorpe. He continued operation of the grocery business at this location for 25 years.

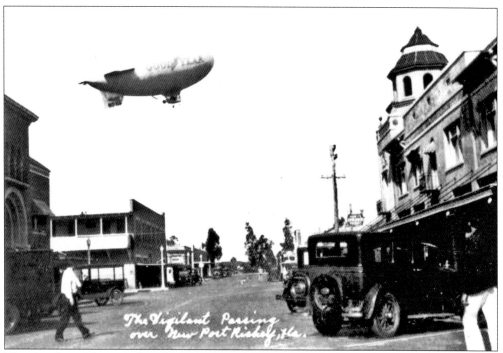

The Goodyear Blimp *Vigilant* flies over downtown north of the Meighan theater (left) and the Pasco Building (right).

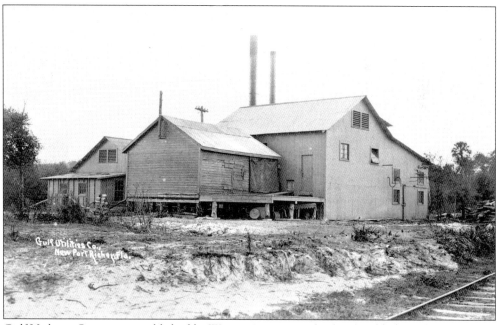

Gulf Utilities Company, established by Warren Burns, was the first local light and power plant. Leland C. Poole was the first person to manage the town electric and ice plant. The boilers ran the steam engines that turned the wood-fired generators. These were later replaced by oil burners. An ice plant was connected with the power plant, furnishing ice to the community.

This scene looking southbound from the Circle (also known as Circle Boulevard) at Orange Lake shows the heart of downtown. Farther south on the left side of the Boulevard, the Pasco Building with its octagonal shaped cupola can be seen. Directly across the street from the Pasco Building is the domed Meighan Theater.

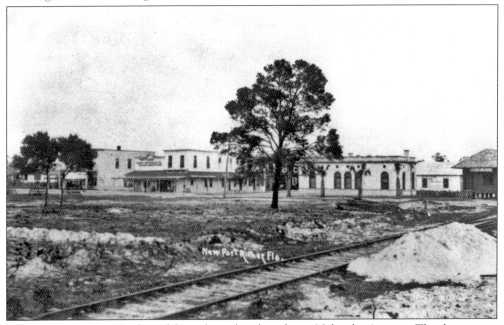

This is a scene of the Boulevard from the railroad tracks on Nebraska Avenue. The depot is on the far right, and the Milbauer building is left of the depot. Across the street to the left of the Milbauer Building is the Port Richey Company.

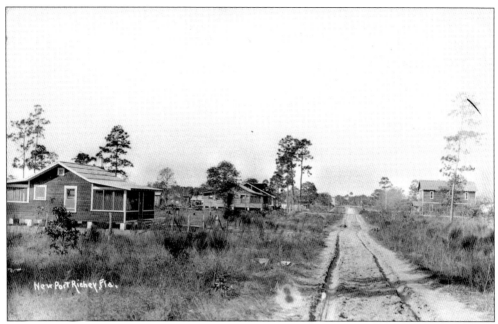

Pictured here is Main Street looking west when it was a dirt road. The building on the right is the Main Street Grammar School. In 1925, this wooden building was replaced by an eight-room, brick building known as the Pierce Elementary School. In 1957, the students were sent to a newly constructed school on Madison Street, which later became the Richey Elementary School.

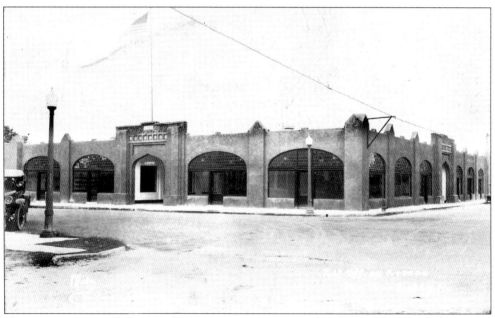

This structure, named the Arcade Building, was constructed in 1927. Offices and shops were located around the sides and front of the building. The post office was located in the northwest corner for 32 years, moving into its own building in 1959.

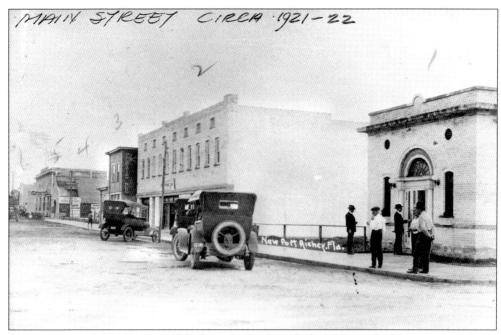

Looking east on Main Street c. 1921 from the Boulevard, the Milbauer building can be seen on the far right. This was the first brick building in town and was completed by George R. Sims in 1919. The structure still stands today.

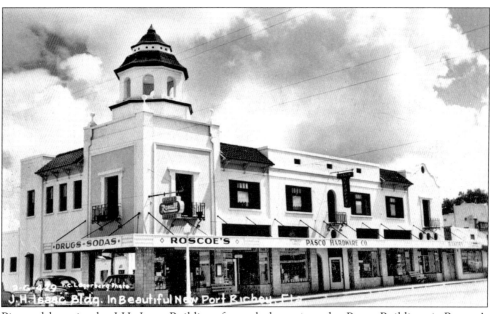

Pictured here in the J.H. Isaac Building, formerly known as the Pasco Building, is Roscoe's Rexall Drugs Store. It was owned and operated by Roscoe Henderson (1906–1998), for 20 years until he retired in 1960. The Pasco Hardware Company is also pictured here. It was founded by John H. Isaac, a pioneer business and civic leader in Pasco County who arrived in New Port Richey in 1931.

Three
SCHOOLS

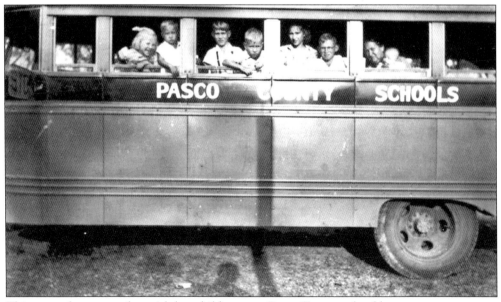

This scene shows a mother with her children on a Pasco County school bus.

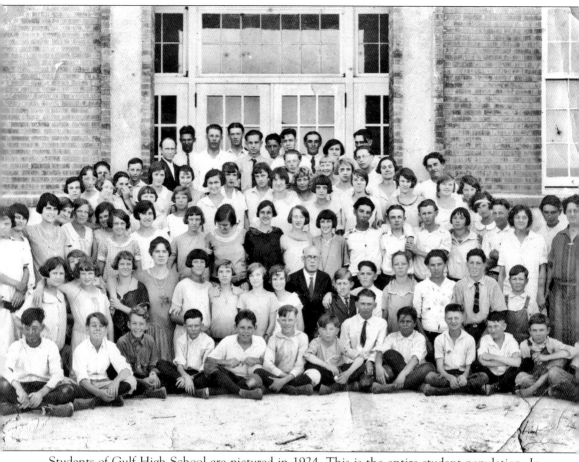

Students of Gulf High School are pictured in 1924. This is the entire student population. In 1924, Gulf had a girls' and boys' basketball team, and in the following year their first school orchestra was established.

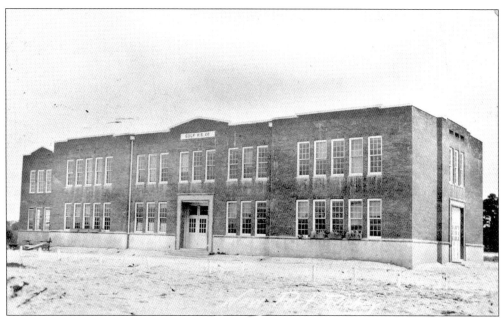

Gulf High School opened on September 18, 1922, for students in grades 6 through 11. This building was constructed at a price of $40,000.

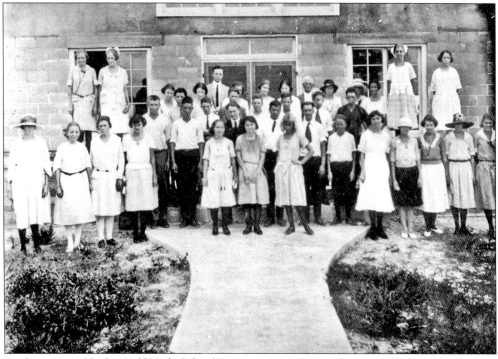

Students assemble for Gulf High School registration on September 1, 1922. Registration took place at the Community Congregational Church. The school building was not ready for its first class until September 18, 1922.

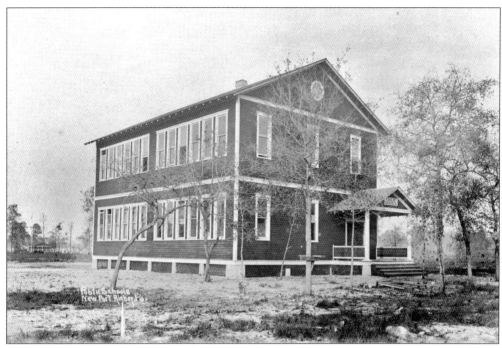

The Main Street Grammar School in New Port Richey, built in 1915, is shown here. A brick school, Pierce Elementary, was later built on the same site.

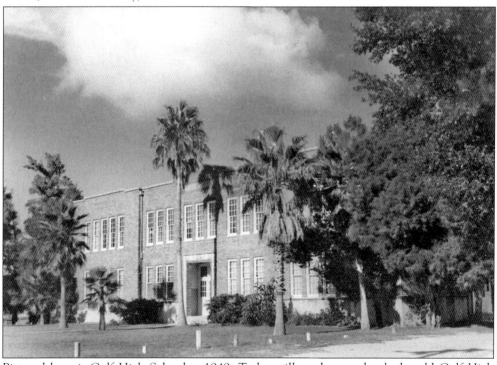

Pictured here is Gulf High School c. 1949. Today still used as a school, the old Gulf High School building is the Harry Schwettman Education Center. Gulf High School is currently at its third location on School Road and Madison Street.

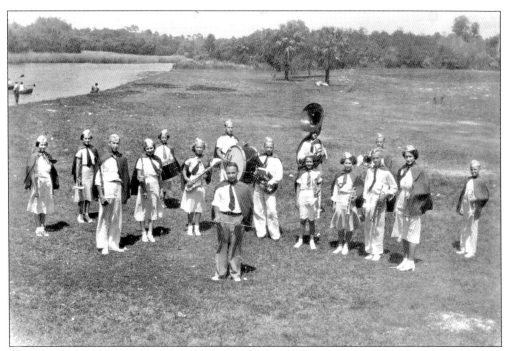

This scene shows the Gulf High School Marching Band c. 1940. Music has been a tradition at Gulf High School from its beginnings in 1925 to the present. Today the band is much larger.

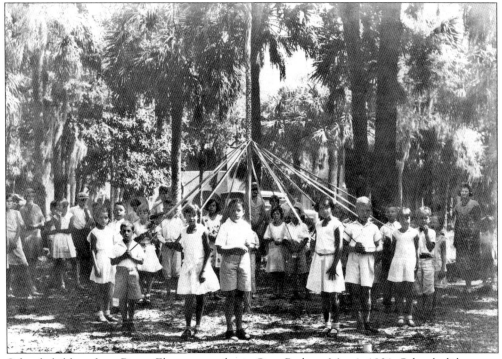

School children from Pierce Elementary play in Sims Park on May 1, 1931. Schools did not yet have playgrounds for the children and Sims Park was the perfect recreation area. Pierce Elementary was within walking distance of the park.

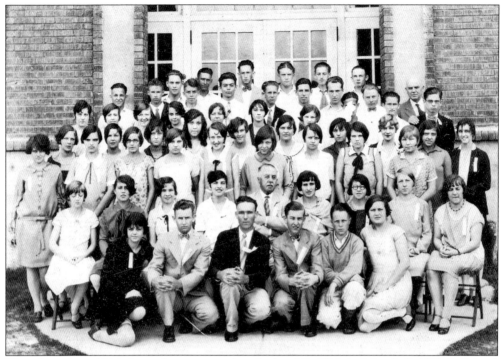

This photo from 1926 shows the entire student body of Gulf High School. Gulf High School progressed during the early years and formed a literary society. The students were also publishing the semi-monthly *Gulf-Hi Life* school news.

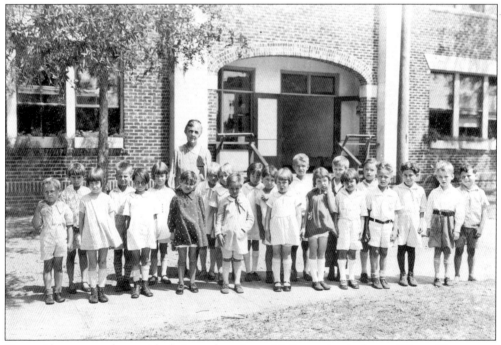

Pictured here are students with their teacher, Anna M. Preetorius, in front of Pierce Elementary School, *c.* 1931. Today, the New Port Richey Public Library occupies this site.

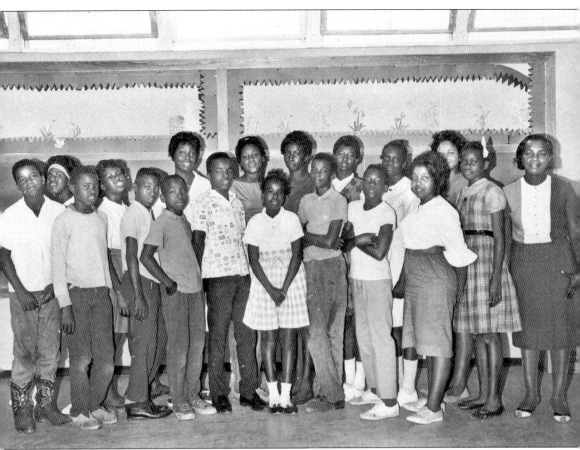

This photo from the 1960s was taken at the Booker T. Washington School located on Pine Hill Road before integration of the Pasco County Schools. Pictured here, from left to right, are (front row) Jimmy Scott, David Lee Winthrop, Randy Merriex, Joseph Merriex, Leroy Merriex, Elizabeth Taylor, Eston Baker Jr., Donnie Porter, Rebecca Porter, Joann Robinson, and teacher Ruby Copeland; (back row) Yvonne Smith, Patsy Mae Arline, Joyce Brown, Janice Winthrop, Ruby Jo Gadson, Altamease Arline, Alzora Blakely, and Sherie Jean Mathis.

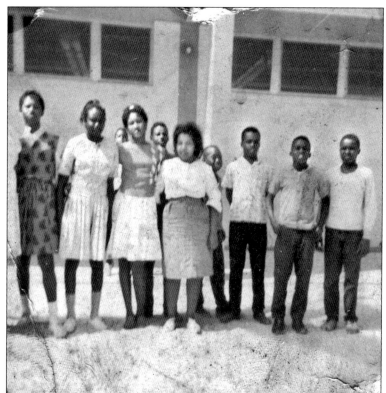

This photo shows students standing outside the segregated, all-black Booker T. Washington School. Students could complete eight grades at this school, but if they wished to continue their education, they had to find their own transportation and pay expenses to attend a school approximately 25 miles south in Clearwater in Pinellas County.

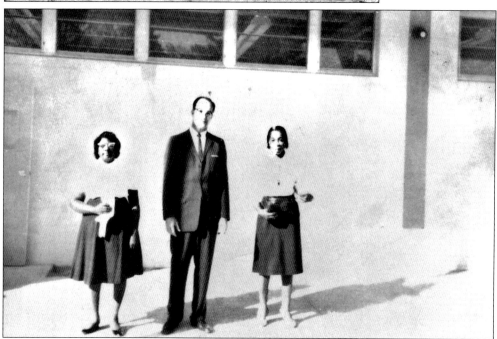

Pictured here, from left to right, are Mattie Lewis, teacher; Chester W. Taylor Jr., superintendent; and Ruby Copeland, principal. Booker T. Washington School was a segregated, all-black school until 1967.

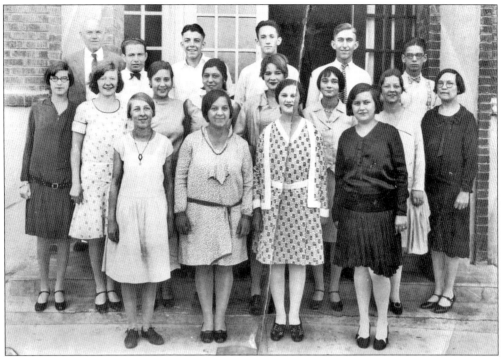

Pictured here is the Gulf High School Class of 1929. Students, from left to right, are as follows: (front row) Meta Hamilton, Charlotte Lautenslager, Anna Hahn, and Pauline Stevenson; (middle row) Maxine Brake, Lucille Batsheler, Helen Littell, Eleanore Thiel, Maxine Pierce, Myrtle Lapham, Leola Baillie, and teacher Miss Fogg; (back row) teacher Mr. Bremner, Casper Cooper, Harold Hunter, Stanley Marrs, Lewis Kolb, and Emil Klepach.

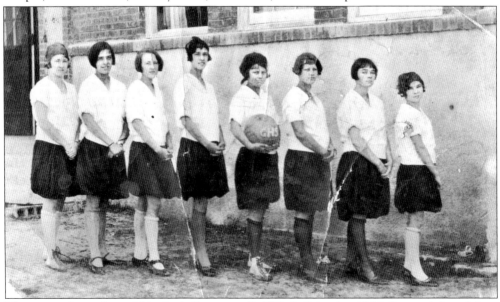

This scene shows the girls' basketball team at Gulf High School c. 1926. Pictured, from left to right, are Bonnie Mitchem, Charlette Dietrich, Mildred Remling, Louise Wilkes, Eva Stevenson, Ione Hill, Myrtle Lapham, and Grace Clark.

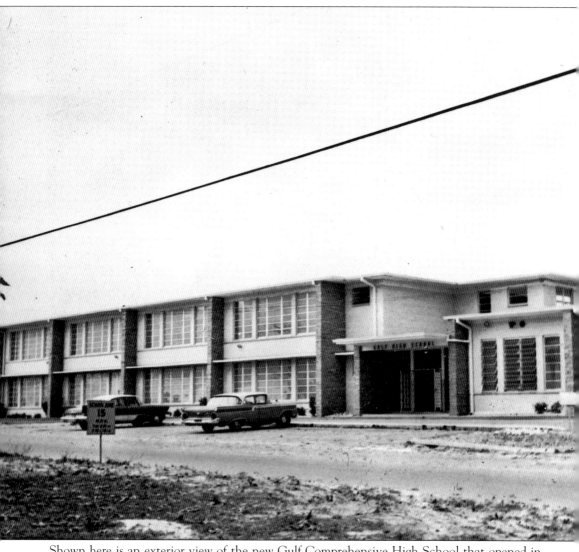

Shown here is an exterior view of the new Gulf Comprehensive High School that opened in 1962 on East Louisiana Avenue. The old Gulf High School, built in 1922 at South Boulevard and Gulf Drive, would become the temporary headquarters for the new Pasco-Hernando Community College. The building would later be used for the Schwettman Education Center. Eventually, this site on East Louisiana would become Gulf Middle School with Gulf High School moving farther south to its present location on School Road.

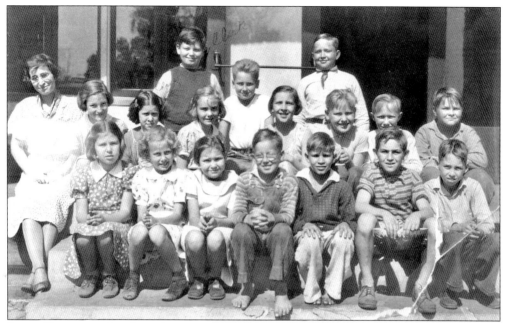

Pierce Elementary fourth graders are pictured here with their teacher, Ellen Norfleet, *c.* 1936. Pictured from left to right are as follows: (front row) Paula Hunt, Leona Knowles, Astrid Equevilley, Sylvester Leigh, Frank Corby, Ronnie Sampson, and Earl Hudson; (middle row) Ellen Norfleet, Kathryn Fraddosio, unidentified, Carolyn Maytum, Helen Colgan, Fred Engle Rey, Bruce Hamilton, and Carlton Jackson; (back row) Clark Carnegie, Harland Kingsley, and Jay Bragg.

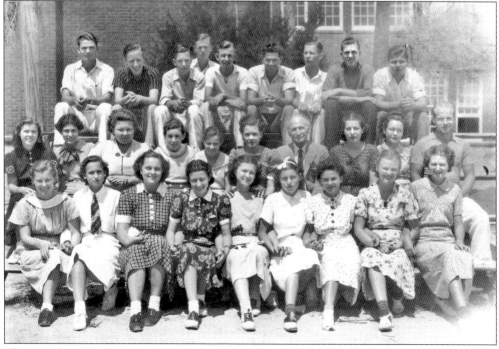

This outside scene shows students in front of Gulf High School *c.* 1930.

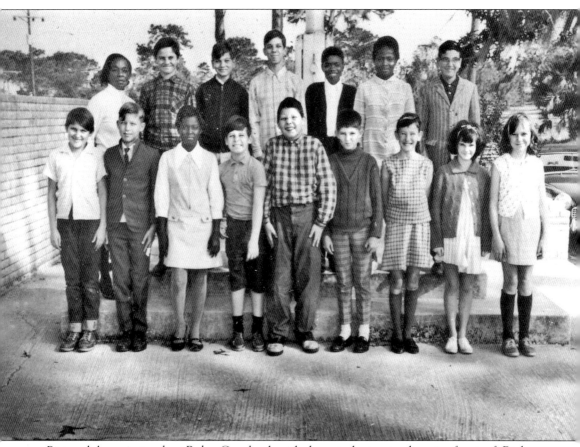

Pictured here is teacher Ruby Copeland with her students standing in front of Richey Elementary School. After integration, Ruby Copeland was transferred from the segregated all-black school Booker T. Washington on Pine Hill Road to the Richey Elementary School on Madison Street.

Four
PEOPLE AND PLACES

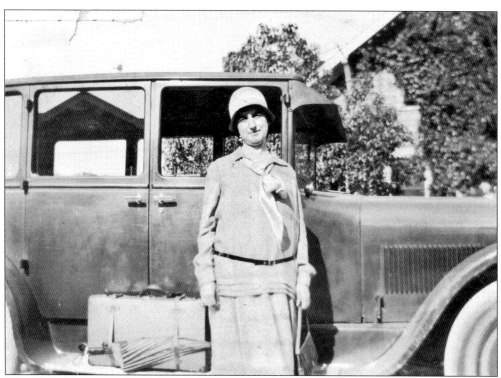

This picture shows an unidentified woman with her suitcase. In the 1920s and 1930s, many tourists of all kinds came to Florida. The wealthy came in search of winter homes. Working families with vacation time came for the beaches. In addition, Tin Can Tourists who lived in campers or tents migrated in groups through the central and Gulf Coast counties such as Pasco County.

An unidentified man is pictured *c.* 1949 holding a rattlesnake. In years gone by, rattlesnakes were far more plentiful than they are today.

This scene from a postcard, *c.* 1917, shows a wildcat that had been killed in the heart of New Port Richey. Pictured here, from left to right, are David Baille and two unidentified persons.

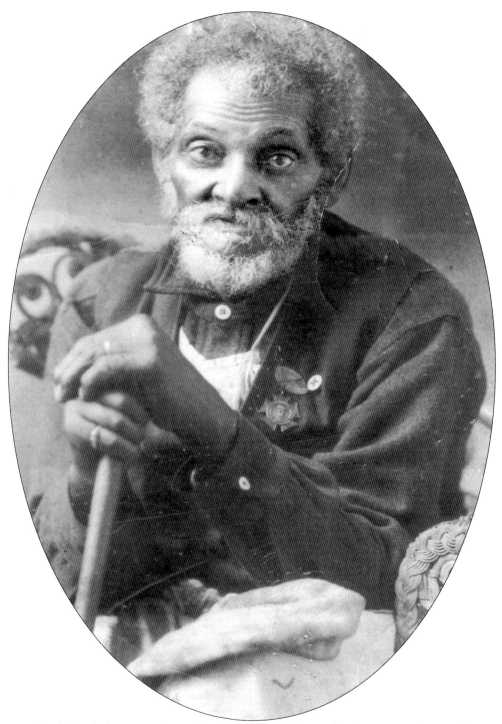

J. Richard Quarls (1833–1925) was known as Christopher Columbus. He was born a slave in South Carolina and fought for the Confederacy during the Civil War. After the war, he moved to Tarpon Springs. African Americans migrated to Tarpon Springs before coming to the Pine Hill section of New Port Richey.

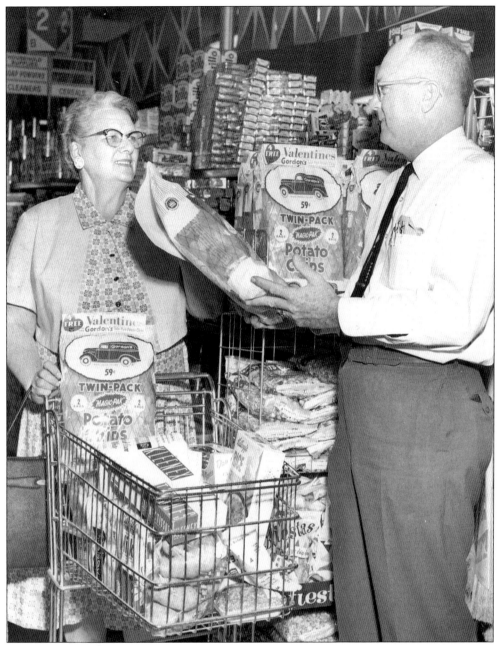

Henry Potter, owner of the IGA store, helps a customer, c. 1952. Henry Potter moved to New Port Richey in 1933 with his wife Vera Mae, his daughter Audrey, and his brother Frank. Henry and Frank bought a store from Mr. and Mrs. Leland Poole and called it Potter Brothers IGA Foodliner. The Potter Brothers IGA Foodliner grew until a larger building was needed, and then they moved from South Boulevard to East Main Street. Around 1977, Henry and Frank retired after 48 years in the grocery business.

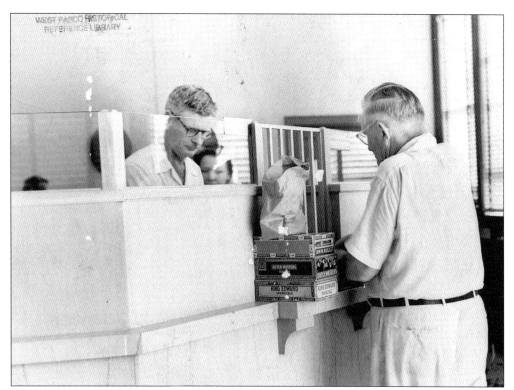

Shown here is the first depositor, John Peters, in the lobby of the Gulf State Bank on Main Street on July 15, 1952. Around 1949, a group of residents from New Port Richey and Tarpon Springs organized and applied for a charter for a commercial bank in New Port Richey. The group was headed by A.L. Ellis, who at that time was president of First National Bank in Tarpon Springs, and the new bank opened for business on July 15, 1952. It was the first bank in the area since the demise of the First State Bank in 1931.

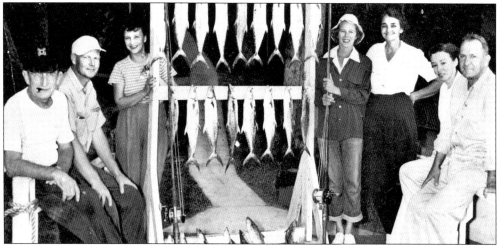

This scene shows the results of a good day's catch with Capt. Ed Lindemann, pictured far left with cap and cigar, in 1950. The West Pasco area has long been one of the finest fishing places to be found. Wide varieties of fish are caught in the waters of the Gulf of Mexico and the fresh water rivers and lakes.

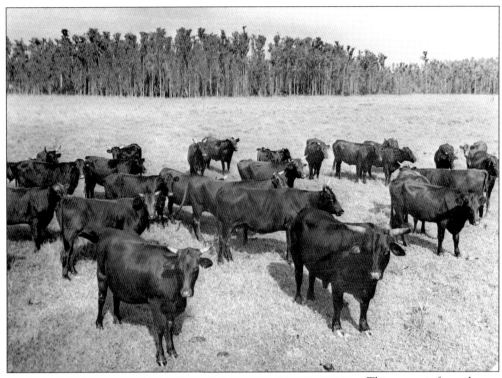

This scene is from the Mitchell Ranch on Odessa Road, formerly Old Gunn Road and now known as State Road 54. Cattle roamed on open ranges before the fence laws were enacted.

Pierce Elementary students Leland C. Poole and Ruth Paine are pictured at Sims Park on May 1, 1931. Sims Park is still used today for many community activities. There is a band shell for concerts and a playground for the children. Boat ramps are also available along the banks of the Pithlachascotee River. The park is also the site of the annual Chasco Fiesta.

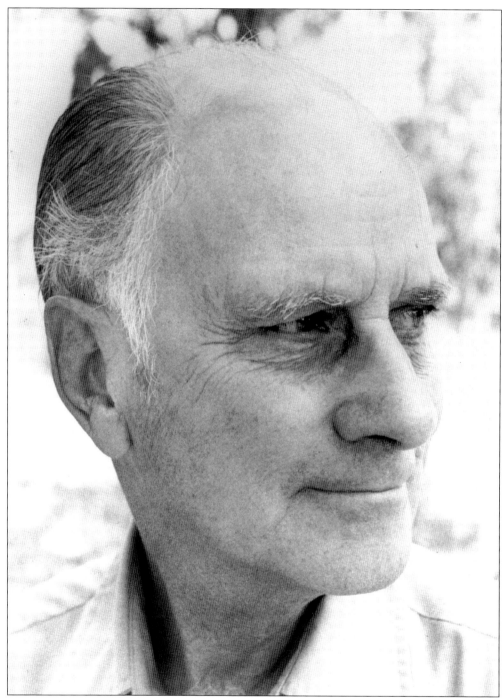

Pictured here is Glen Dill, a broadcaster, writer, and public speaker. For many years, he wrote nearly 1,000 columns on North Suncoast and Florida history in the *Suncoast News*. Mr. Dill gave more than 1,000 speeches and spent 25 years on radio and television in St. Petersburg and New Port Richey.

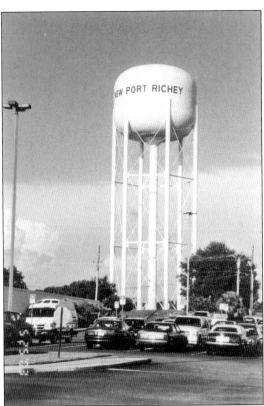

Captured in this 2003 photograph is the New Port Richey water tower near Gulf High School and Community Hospital.

This 1950 photograph shows the parking lot of Hawn's Fish House. Eating at fish houses has always been popular in the area.

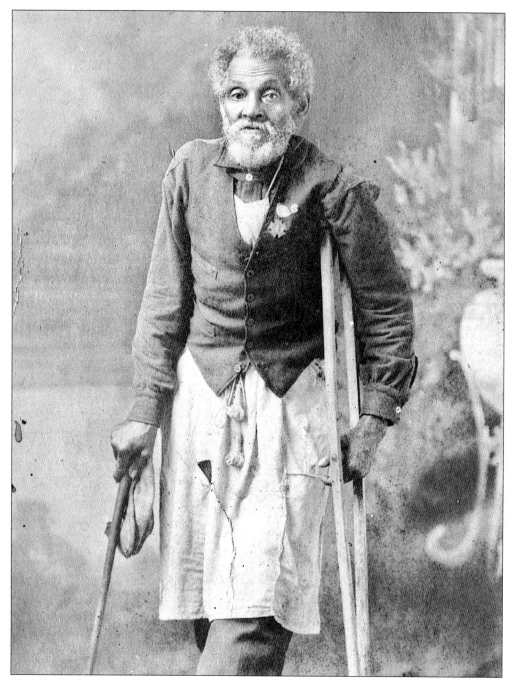

This Civil War veteran with crutch and cane, J. Richard Quarls, also known as Christopher Columbus, is pictured here. Mr. Quarls was wounded in the leg during the war. In 1916, he received a Florida Confederate Soldier pension from the U.S. government. Upon his death in 1925, his pension was paid to his wife until her death in 1951.

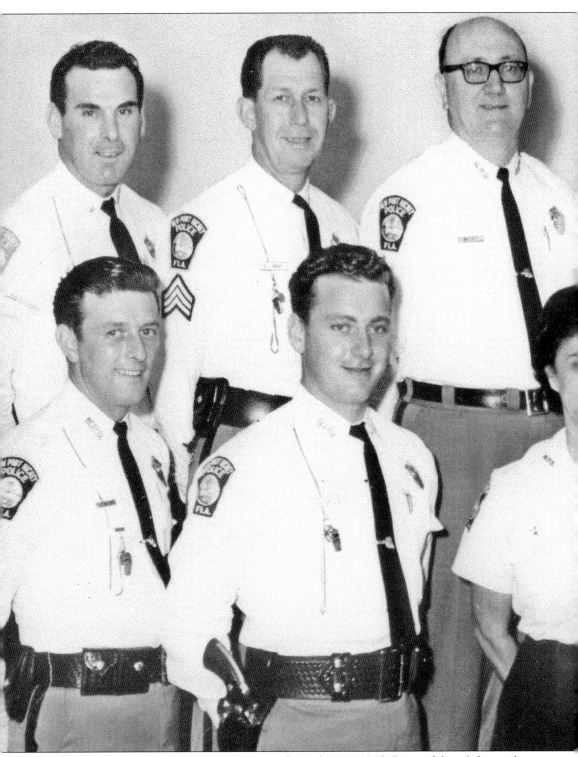

The New Port Richey Police Department is shown here in 1965. Pictured from left to right are the following: (front row) Larry Weldon, John Short, Bunny Minton (dispatcher), Chief Vergie

Barga, and Sgt. Joe Peak; (back row) Bill Sharrow, Sgt. Dick Barga, Bill McCart (dispatcher), Chuck Roberts (dispatcher), Dave Meldon, and Tom Chittum.

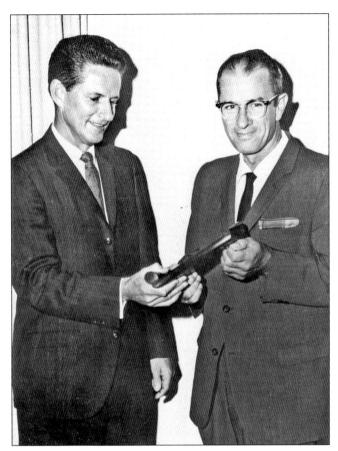

Fred Marchman, on right, receives an Outstanding Citizen Award from the Greater New Port Richey Chamber of Commerce president Raymond L. Sirmons in 1963.

Pictured here is Fred's Fish House c. 1950. Smoke houses were dear to the heart of the pioneer family, and smoked mullet was a local favorite.

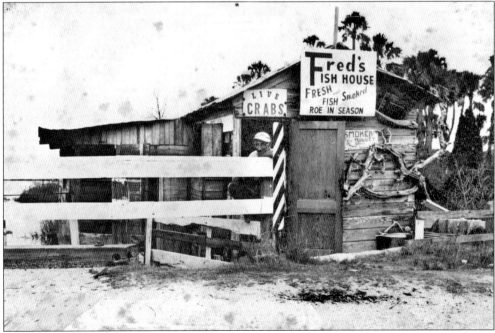

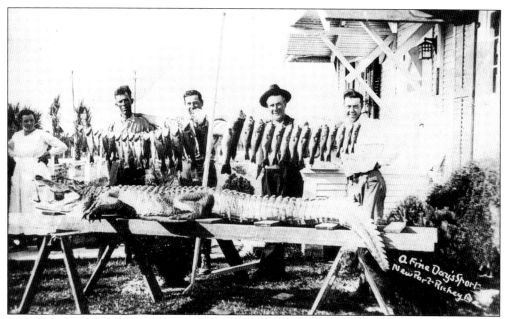

This photo is labeled "A Fine Day's Sport." When alligators were in abundance, they were hunted for sport and their hides, to the point of near extinction.

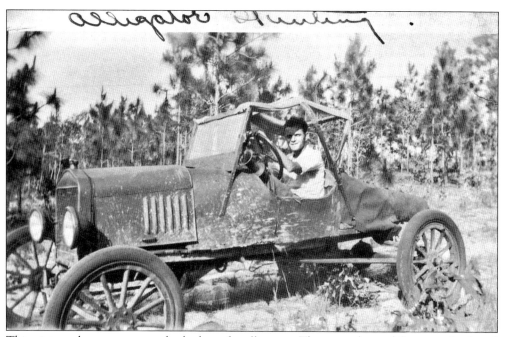

This picture shows a man on the lookout for alligators. They were hunted for sport, food, and hides. Laws would eventually be passed in Florida protecting the endangered gators. Alligators are no longer an endangered species in the state, but it would be difficult to spot one today along the banks of the Pithlachascotee River.

The shuffleboard club poses for a photo c. 1950s. Clubs were the best way to meet new friends and enjoy community activities together.

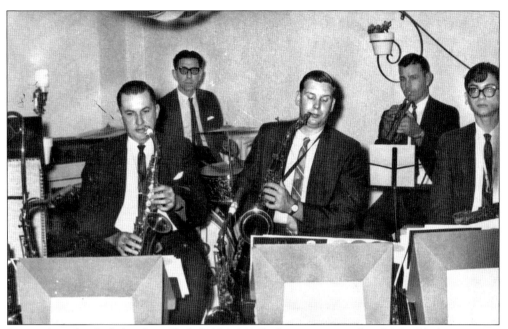

Pictured on the far left is Jim Clark (1926–2001) playing in a jazz band. Mr. Clark was music director at Gulf High School from 1950 to 1956. Clark played saxophone and directed a local community jazz band.

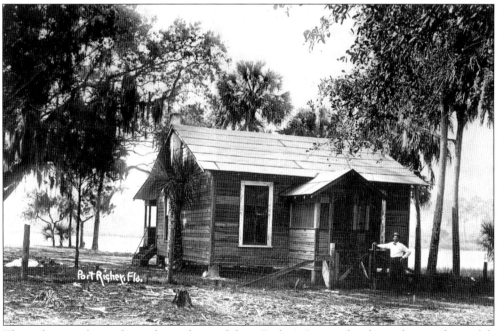

This cabin was located just down the road from Bailey's Inn—a local spot known for its fish stories. Almost everyone goes fishing in New Port Richey, and people are inclined to believe the stories about the "big one that got away."

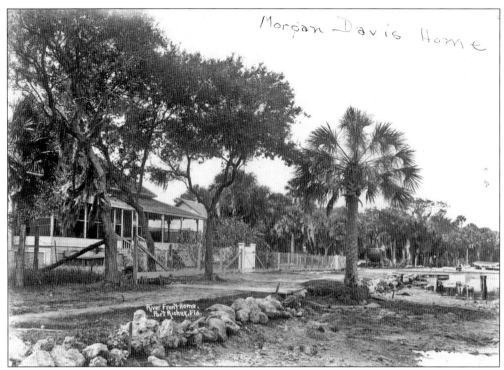

The riverfront home of Morgan Davis was located on Dixie Highway along the Pithlachascotee River.

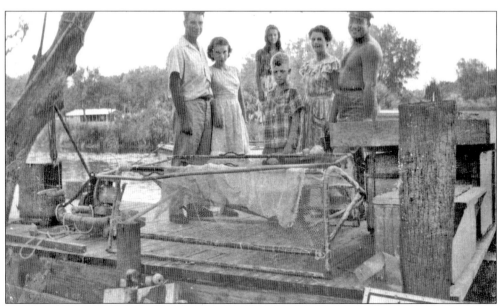

The first shrimp net in New Port Richey was used c. 1947. Today, shrimping is still popular in the Gulf of Mexico.

Ronnie Sampson (left) and Billy Wilson (right) sit inside the New Port Richey Railway Depot.

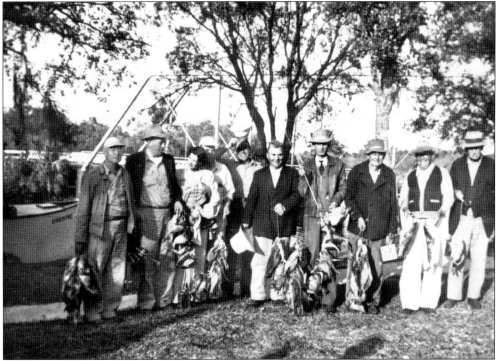

This scene shows the end of a good day's catch in 1949. Fishing in New Port Richey for food, sport, or just a relaxing day is still a major pastime.

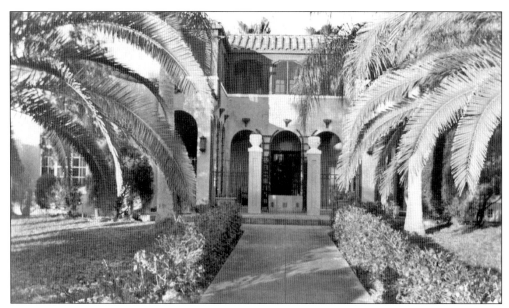

Pictured here is the home of S.O. Aungst at Jasmine Point in 1945. Jasmine Point was developed as an exclusive subdivision soon after the incorporation of New Port Richey in 1924.

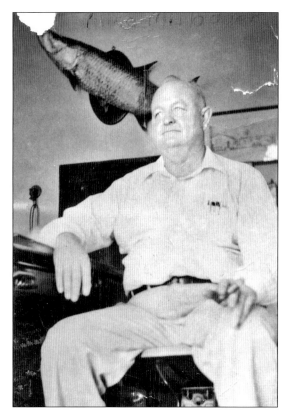

Michael Milbauer (1894–1964) is shown with a trophy fish on the wall. He sits inside the Milbauer Building at the southeast corner of Main Street and the Boulevard. Built in 1919, the building was originally used as a land office by the Port Richey Company.

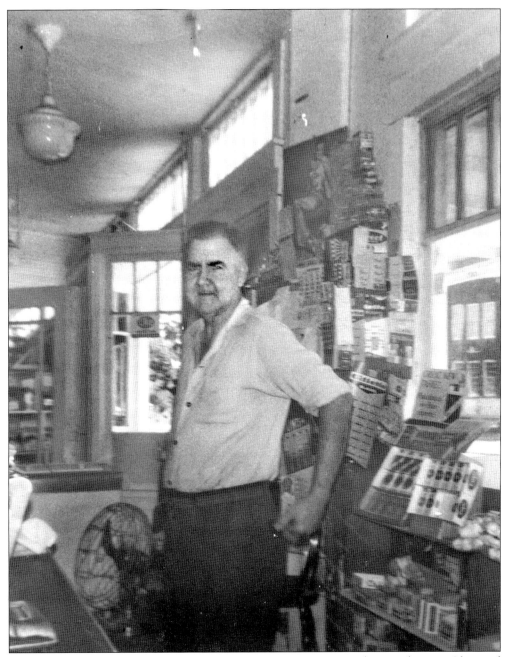

Pictured here is Zane Rankin inside his grocery store, c. 1960. Rankin was born in Ohio and arrived in New Port Richey in 1923 with his parents when he was 17 years old. He is a second cousin to Zane Grey, the famous writer of the Old West.

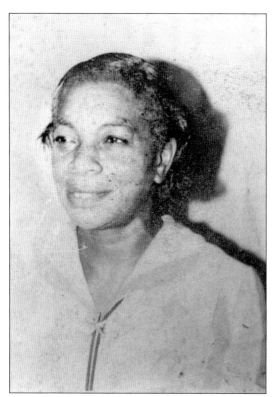

Ruby Copeland, teacher, musician, and poet, is pictured here. Mrs. Copeland taught at the Booker T. Washington School before integration of the public schools in Pasco County. After integration, she taught at Richey Elementary School on Madison Street.

Annie Mack, affectionately known as "Mother Mack," was the mother of Ruby Copeland, a teacher at the Booker T. Washington School on Pine Hill Road in New Port Richey.

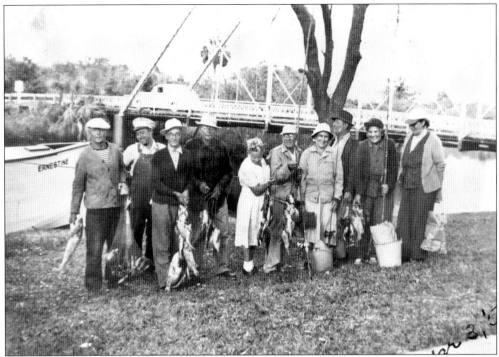

This 1950 scene features once again the good fishing of the area. Pictured in background is the iron bridge crossing the Pithlachascotee River.

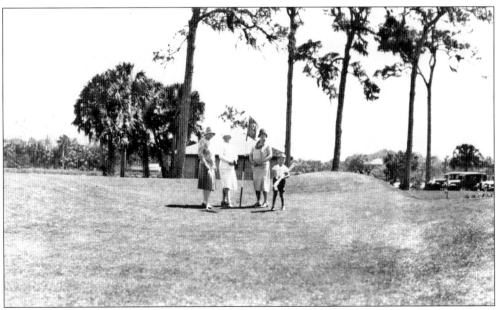

Three ladies with a very young caddy are shown here. In the 1920s and 1930s, golfing was a very popular draw for New Port Richey. Gene Sarazen (1902–1999), of golfing fame, accepted the position of golf pro at the Jasmine Point Golf Club and was influential in bringing both the famous and the wealthy to the area.

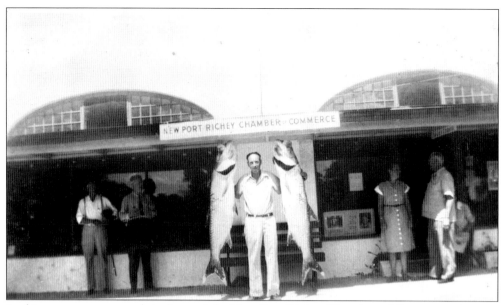

In this scene, a man stands in front of the New Port Richey Chamber of Commerce showing two large fish, c. 1946. It appears to be an advertisement for would-be tourists suggesting how big the fish really are in New Port Richey.

A.H. Stevens was the principal of Gulf High School from 1945 to 1949. Mr. Stevens also served on the county commission.

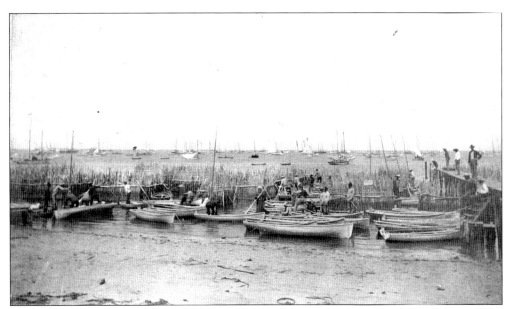

This scene shows a sponge fleet off Baillie's Bluff, looking outward into the Gulf of Mexico. The bluff is located about halfway between the mouths of the Pithlachascotee River to the north and the Anclote River to the south. The sponge fleet would bring their catch of sponges into Baillie's Bluff for cleaning and drying.

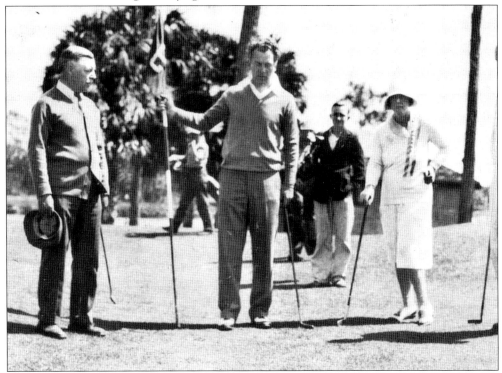

Pictured here are some of the many wealthy people that spent their leisure time golfing in New Port Richey. Adjoining the exclusive subdivision of Jasmine Point, a beautiful golf course was built. The famous golfer Gene Sarazen accepted a position as pro at the golf course.

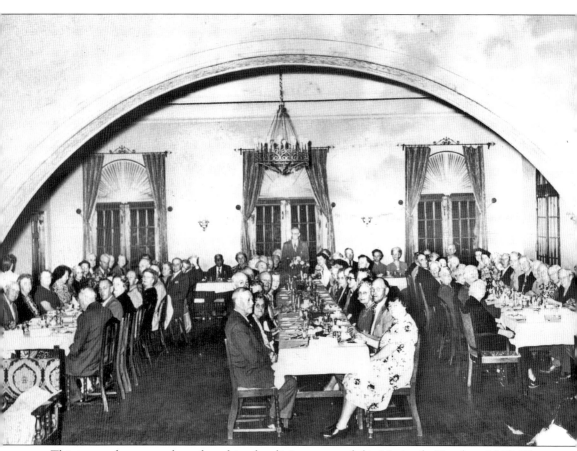

This scene shows people gathered in the dining room of the Hacienda Hotel, c. 1950. The beautiful Hacienda Hotel was constructed in 1927 in the hope of attracting the Hollywood movie industry to the New Port Richey area. Comedian Ed Wynn was master of ceremonies at its opening. This aspiration never materialized, and in just a few years the hotel went bankrupt during the Great Depression. In subsequent years, the building changed hands several times. The Hacienda is no longer operated as a hotel and is now known as the Hacienda Home.

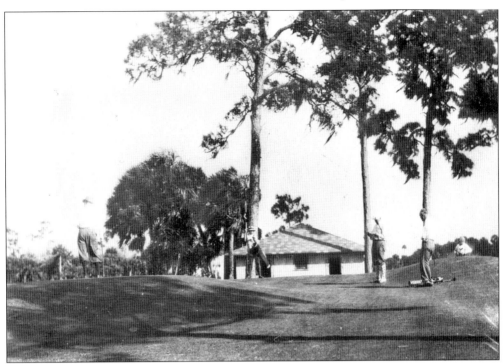

This postcard shows golfers enjoying their day at the Jasmine Point Golf Club. Many famous and wealthy people came to play here.

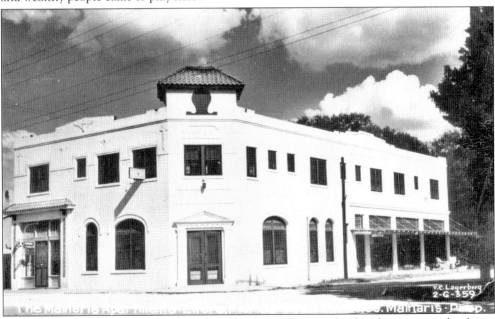

Pictured here is the old Elfers State Bank Building. This area landmark is noteworthy for its architectural significance and for the fact that, despite its name, it was never used as a bank. It was completed in 1926 just as the Florida boom collapsed, and the banking industry was left in shambles. With its original purpose abandoned, it has been used as a retail and residential structure since that time.

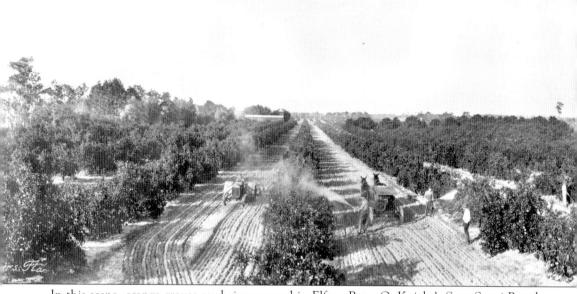

In this scene, orange groves are being sprayed in Elfers. Peter O. Knight's Sans Souci Ranch and Grove Site was one of the earliest citrus groves in western Pasco County in the early 1900s. As the citrus industry became a way of life, several influential businessmen formed the Elfers Citrus Growers Association, and in 1920, a packing house was built where fruit would be prepared for shipment.

Pictured here is C.L. Baker cementing the walls of his "Palm House" c. 1946. This house was built using cut palm trees.

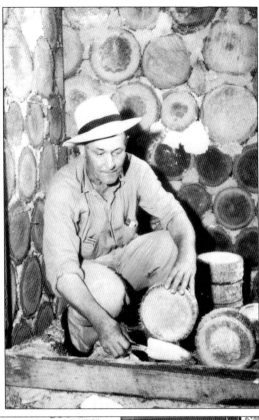

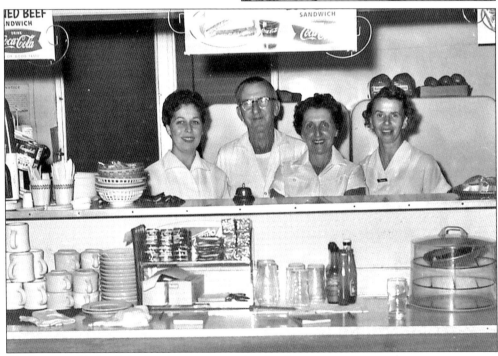

Workers stand behind the lunch counter at a local café.

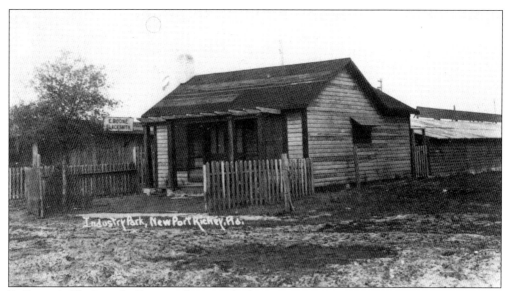

E. Boone's Blacksmith Shop is photographed c. 1916 in New Port Richey's Industry Park, located near the corner of Jefferson Street and Montana Avenue.

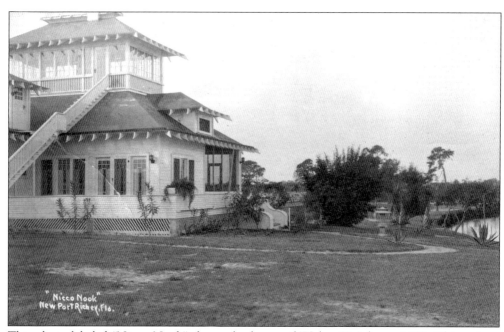

This photo labeled "Nicco Nook" shows the home of Walter K. Jahn c. 1920. This unique home, located north of Sims Park, burned to the ground in 1922.

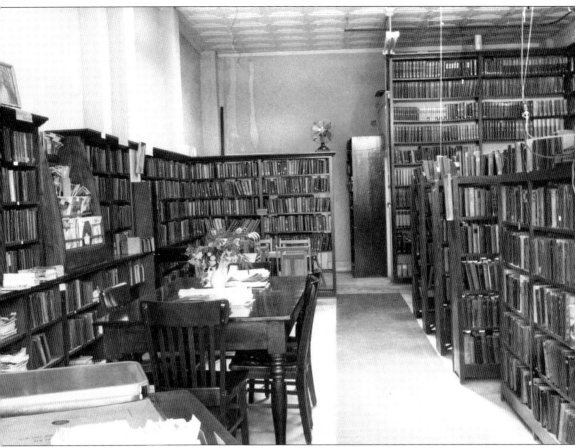

Pictured here are books on the shelves of the New Port Richey Library in 1950. Libraries were an important asset to the community in the early days of New Port Richey. The first library was the Avery Public Library, formed in 1919.

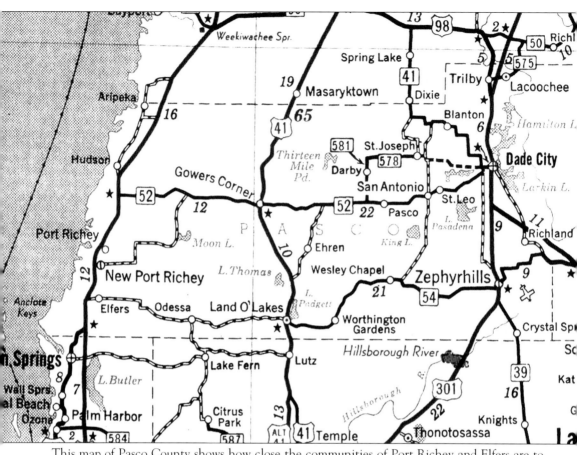

This map of Pasco County shows how close the communities of Port Richey and Elfers are to New Port Richey. Tarpon Springs is approximately eight miles to the south in Pinellas County.

Five

COMMUNITY

This c. 1916 scene from a postcard shows the Cotee River Community Club, located in Enchantment Park, now Sims Park. This was the civic amusement and recreation center for the community.

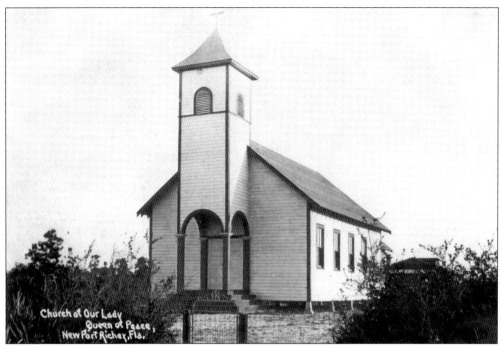

The first Roman Catholic church in western Pasco County, Our Lady Queen of Peace, was located on Washington Street. It was constructed in 1919 with only seven Catholic families living in the area. This church is being restored and has been moved to Sims Park behind the West Pasco Historical Society.

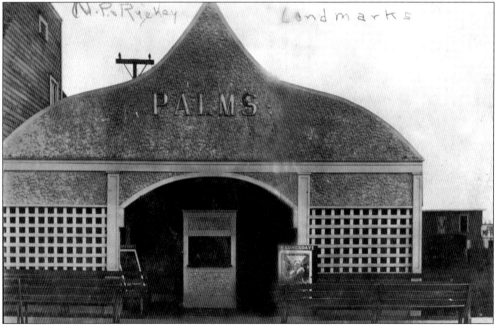

The Palms Theater opened in 1921 for community events and moving picture shows. In later years, the theater was used for a feed store and then a recreation hall for children. The Palms Theater burned down in 1938 and was not rebuilt.

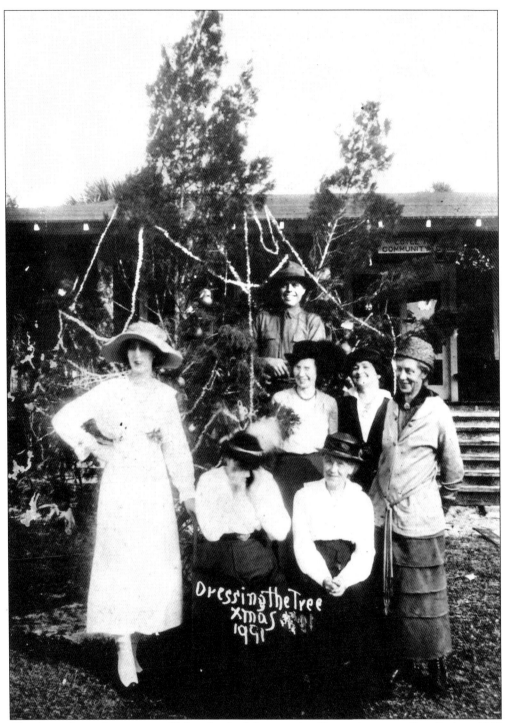

Dressing the Tree
Xmas
1991

The Cotee River Community Club is finished dressing the Christmas tree in Sims Park in 1919 (the year was transposed on the photo). The club raised money through events such as ice cream socials and used it for many civic affairs. They accomplished much for the people of New Port Richey.

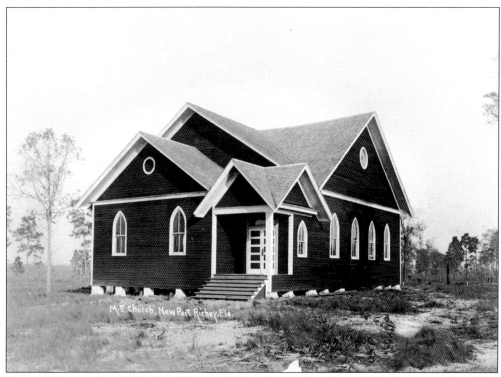

Pictured here is the Methodist Episcopal Church completed in 1918. In 1940, the Elfers Methodist Church merged with the New Port Richey Methodist Episcopal Church.

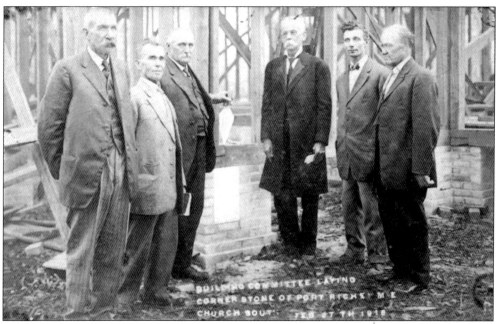

This 1918 photo shows the building committee laying the cornerstone of the Methodist Episcopal church.

Pictured here is the civic club located in Sims Park c. 1960. It was originally built in 1916 as a community club house. The building was donated to the Woman's Club by George Sims in 1924.

The New Port Richey Shuffleboard and Tourist Club was formed in 1935 for entertainment and civic affairs. It was definitely an asset to the community.

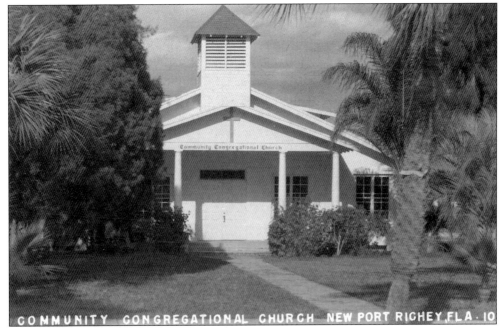

COMMUNITY CONGREGATIONAL CHURCH NEW PORT RICHEY, FLA · 10

Pictured here is the Community Congregational Church. During the summer of 1921, this building was under construction on two lots donated by George R. Sims. It was located on the north side of Orange Lake, facing the Circle.

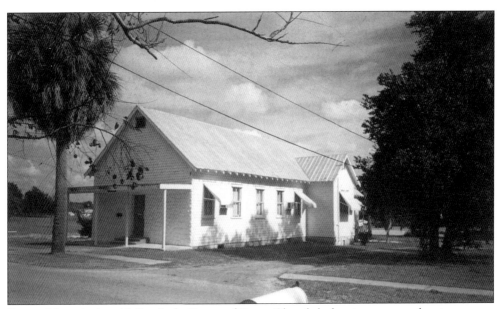

Pictured here is the old Our Lady Queen of Peace Church before it was moved to its present location behind the West Pasco Historical Society in Sims Park. The new church was built in 1965 on 10 acres of land and is presently located at Highway 19 and High Street. (Courtesy of Jackie Owen.)

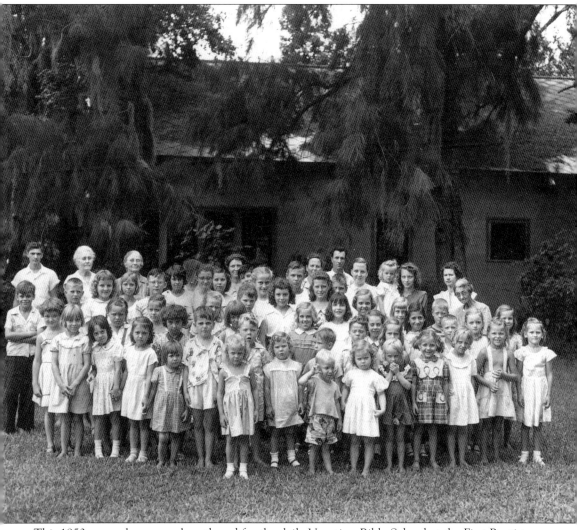

This 1953 scene shows people gathered for the daily Vacation Bible School at the First Baptist Missionary Church.

Pictured here are members of the Elfers Baptist Church in 1949. The church was originally founded in 1876.

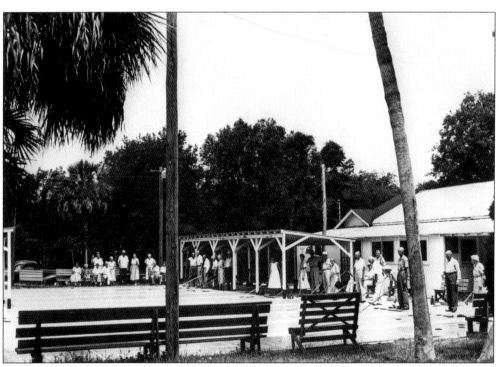

The New Port Richey Shuffleboard Club on South Boulevard is photographed c. 1952.

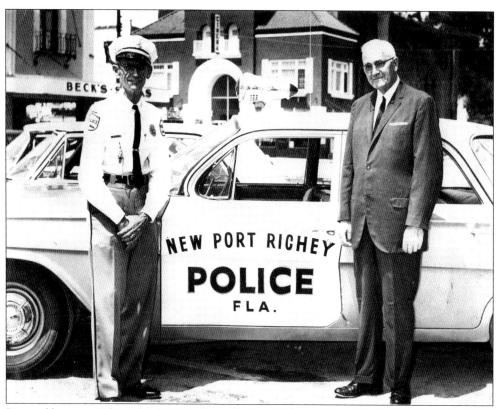

Pictured here are Police Chief Verbie Barga (left) and Mayor Claire Kohler (right), *c.* 1962. Mr. Kohler was mayor from 1957 until 1970.

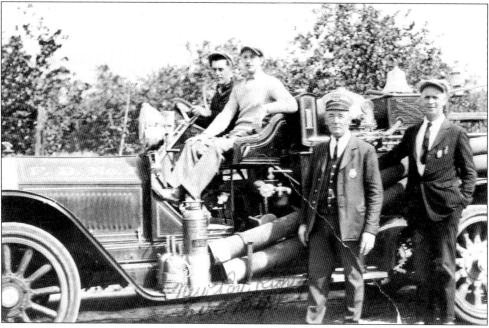

The first local volunteer fire department was formed in 1922.

POOLE'S Grocery

HAMBURGER, lean 2 lbs. 25c

BEST WESTERN		FLORIDA	
Round Steak	30c	Round Steak	20c
Sirloin	32c	Sirloin	23c
T-Bone	35c	T-Bone	25c
Lamb Shoulder	21c	Chuck Roast	14c
Veal Cutlet	34c	Shoulder Roast	16c

LAMB CHOPS — VEAL CHOPS — PORK CHOPS

GREEN BEANS — GREEN PEPPERS
FRESH SPINACH — CAULIFLOWER

POTATOES, No. 1 Irish 10 lbs. 19c

MILK, Tall Golden Key 6c

SWEET POTATOES		10 lbs. 25c
COFFEE	19c	ONIONS 4 lbs. 15c
RICE,	4 lbs. 25c	APPLES 4 lbs. 17c
KELLOGG'S CORN FLAKES		2 pkgs. 17c

NEW YORK STATE CHEESE

REGISTER'S CASH GROCERY

SWEET POTATOES	5 lbs. 12c
APPLES—York's or Grimes Golden	5 lbs. 19c
POTATOES	10 Pounds 19c
CARROTS	2 bunches for 15c
TOMATOES, Nice California	lb. 10c
CABBAGE, lb.	4c
LEMONS, dozen	19c
APPLES—Eating (Delicious), dozen	30c
CORNED BEEF, can	15c
CORN FLAKES (Jersey)	2 for 15c
MILK, Tall cans	3 for 19c

BEEF ROAST, lb.	15c	PORK CHOPS Lb.	32c
BEEF STEW, lb.	10c	LAMB Rib, lb.	30c
STEAK Round, lb.	20c	LAMB SHOULDER Lb.	22c
STEAK SIRLOIN, lb.	23c	HAM HOCKS Lb.	19c
HAMBURGER lb.	15c	WEINERS lb.	20c

These 1935 advertisements for Poole's Grocery (left) and Register's Cash Grocery (right) originally appeared in the *New Port Richey Press.*

FRESH TEXAS

TURKEYS

FOR CHRISTMAS

BEST WESTERN BEEF

Pot Roast, lb.	20c
Prime Rib Beef, lb.	30c
Round Steak, lb.	30c
Sirloin Steak, lb.	35c

FLORIDA BEEF

Chuck Roast, lb.	15c
Rib Stew, lb.	10c
Round Steak, lb.	20c
Sirloin Steak, lb.	23c
Lamb Shoulders, lb.	23c
Lamb Stew,	2 lbs. 25c
Pork Chops, lb.	32c

1 lb. Chili Con Carne	29c
Tomatoes, No. 2 can	23c
MOTHERS OATS	23c
CORN, No. 2 can	10c
French Markets Coffee, in glass, lb.	28c
Large APPLES	5 lbs. 19c
Paper Shell PECANS and Walnuts, lb.	25c

FRESH OYSTERS

PHONE 90 — WE DELIVER

PUBLIC MARKET

ALBERT E. COBURN, Prop.

This 1935 advertisement in the *New Port Richey Press* was for the Public Market.

Laura A. Powell (right) is pictured at a 1951 hobby show. Miss Powell came to New Port Richey from Cleveland, Ohio, and served seven years as librarian at the Avery Public Library. The library was located in the Municipal Building at 113 East Main Street. She also wrote the newspaper column *Library Notes*, which appeared weekly in the *New Port Richey Press*.

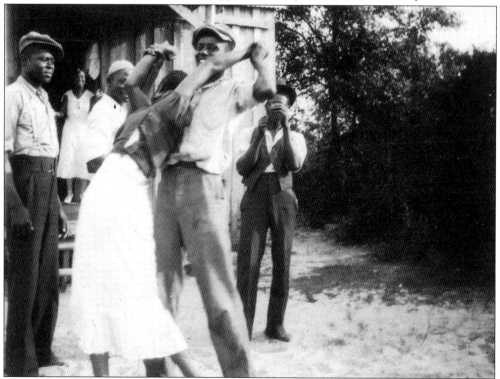

This unidentified photo shows young people enjoying themselves *c.* 1930s.

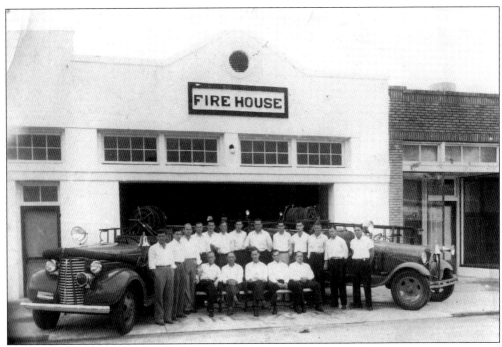

New Port Richey Fire Department is shown here *c.* 1940. These members, from left to right, are (front row) Wilson Fowler, Spencer Bentley, Bob Sims, Joe Fraddosio, and James Grey; (back row) Henry Falany, Joe D'Accardi, Dick Marrs, Oscar Wick, Basil Gaines, Lester Hill, John O'Hara, James Vickers, James Weiskopf, Robert Foskett, Curtis Falany, Bill Fraddosio, and Ted Arnett.

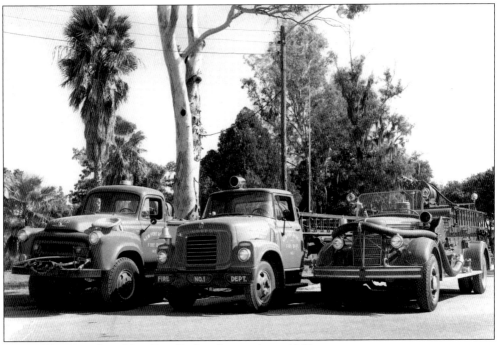

Pictured here are three New Port Richey fire trucks, *c.* 1959.

Pictured here are members of the Indiana Club c. 1950s. There were and still are numerous clubs and organizations in the West Pasco area. The many clubs and organizations of the area have always been popular and have provided a service to the community. Most of the clubs are cultural, educational, political, civic, entertaining, or charitable in nature, but all contribute greatly to our community.

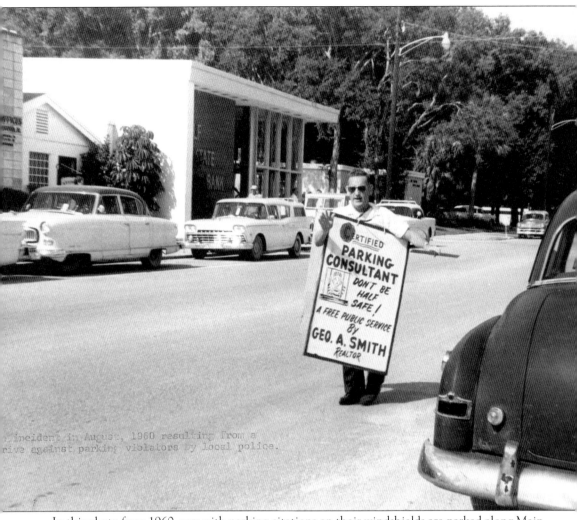

In this photo from 1960, cars with parking citations on their windshields are parked along Main Street. To counteract this drive against parking violators by local police, this man is offering his services as a parking consultant.

Six

PARKS, RIVERS, AND BRIDGES

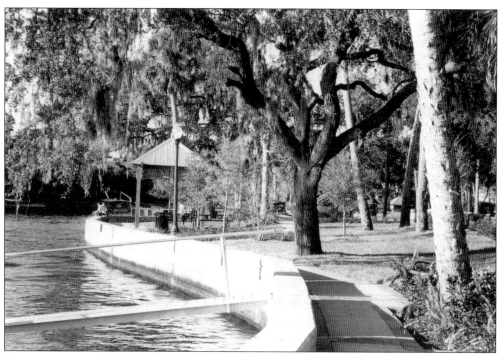

This scene shows the Pithlachascotee River as it looks today with new sea walls and sidewalks on its banks. The river is still an inviting scene, and this photo could easily be mistaken for a much older one.

The sun sets behind the palm trees, casting its reflection upon the Pithlachascotee River. According to archaeologists, people inhabited the banks of this beautiful river more than 10,000 years ago.

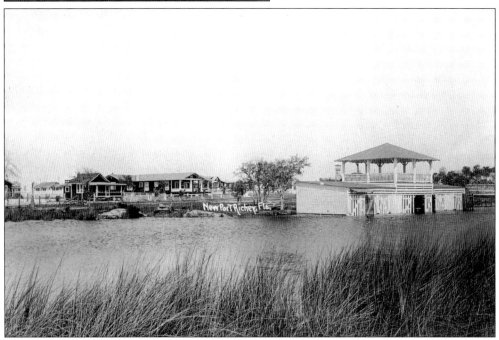

This photo shows the boathouse constructed in 1925. It was located on the Pithlachascotee River at Sims Park. Now used as a gazebo, it is located on land in front of the West Pasco Historical Society in Sims Park.

This scene from a postcard shows the enchanting Pithlachascotee River richly endowed by nature.

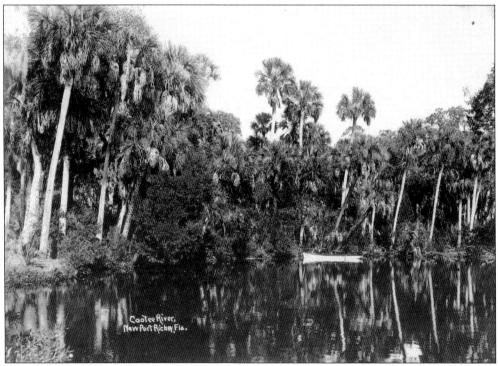

A man enjoys the scenic beauty in a boat on the river surrounded by natural palm groves.

Pictured here is the unveiling of the New Port Richey Veterans Memorial placed at Orange Lake in the heart of downtown New Port Richey. The plaque found on this stone monument reads, "Dedicated to the honor and memory of the men and women of West Pasco County who served in our nation's wars." This monument was rededicated on Veterans Day, November 11, 1986, by Paradise Post 79 of the American Legion.

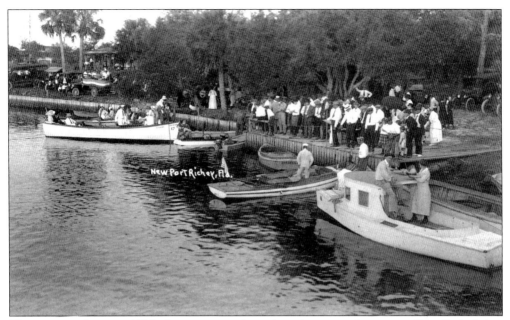

This vintage photo, c. 1922, shows groups of people gathering at the river in Sims Park. It has been a familiar scene both then and now. However, today you will not see women wearing fancy dresses or men wearing white shirts with ties in the park.

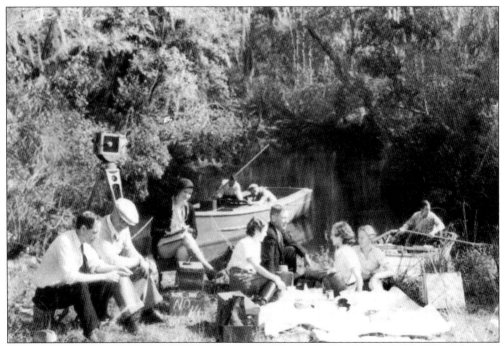

In this scene of filming on the river, the people are unidentified and the year is unknown. However, Paramount Studios was here in 1933, seeking a location for a motion picture.

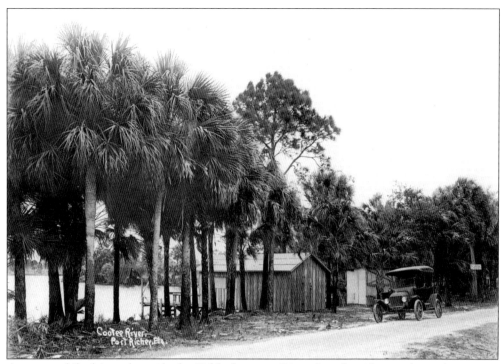

An automobile drives alongside the Pithlachascotee River. Local residents refer to the river as the Cotee River, as that is much easier to pronounce, but at one time it was referred to as the Cootee River.

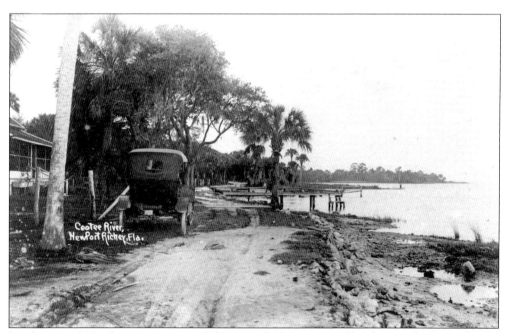

In this *c.* 1923 photo, an automobile is parked on a muddy dirt road alongside the Pithlachascotee River.

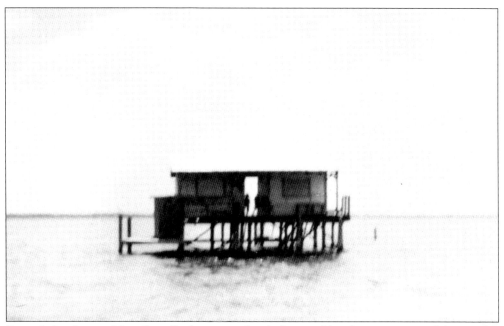

Several families in New Port Richey owned stilt houses like the one pictured here. This structure was located about one mile offshore along the Pasco County coastline on the Gulf of Mexico. These buildings were more commonly identified as stilt shacks or fishing camps.

Pictured here is a stilt house. Originally, these shacks were erected by commercial fisherman, and eventually they were used as getaways for swimming and fishing by local families. Arriving in rowboats, families would spend weekends and sometimes entire vacations in these houses.

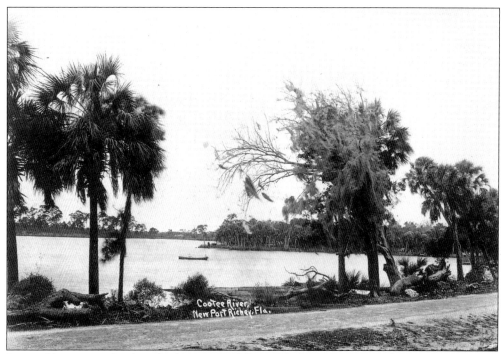

Pictured here is another breathtaking view of the Pithlachascotee River. The river originates at Crews Lake and meanders 41 miles southwest, proceeding under bridges at Rowan Road and then Grand Boulevard. Next it crosses Main Street at New Port Richey before it turns north through Port Richey and empties into the Gulf of Mexico.

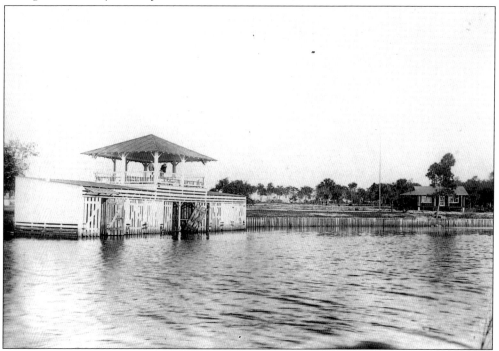

Pictured here is a *c.* 1925 view of the boathouse on the Pithlachascotee River in Sims Park.

This old photo shows the camping ground at Enchantment Park, now known as Sims Park.

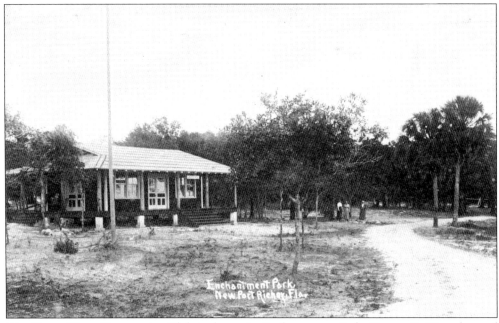

The Cotee River Community Club is shown in Enchantment Park. George R. Sims donated the clubhouse to the Women's Civic Club.

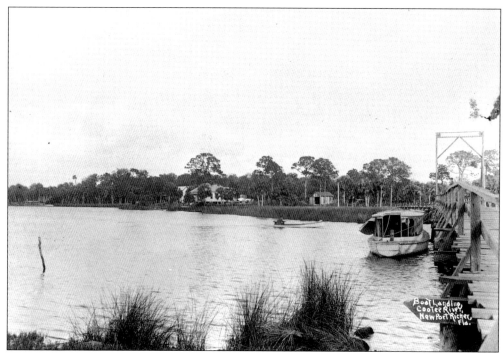

The boat landing on the Pithlachascotee River, referred to as the Cootee River, can be seen in this picture. The term "Cootee River" was short-lived. The river is commonly called the Cotee River.

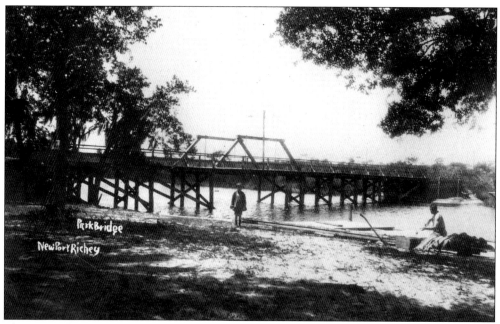

This scene from a postcard, c. 1921, shows Park Bridge on Bridge Street. This old wooden bridge was the first one to cross over the Pithlachascotee River on Bridge Street. Years later, a second bridge and then the current third bridge were built. Also, Bridge Street was renamed Main Street.

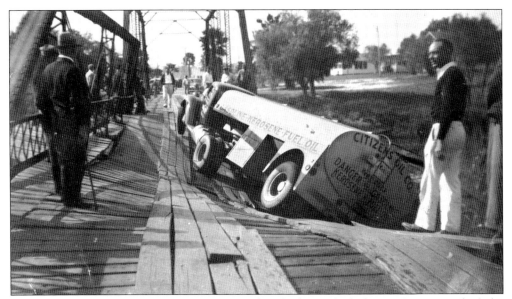

In this scene from 1939, a gasoline tank truck, which weighed about 17 tons, crushed the weakened bridge that crosses the Pithlachascotee River on South Boulevard. The truck remained on the bridge for two days, and after four days of work by the state road department the repaired bridge was reopened.

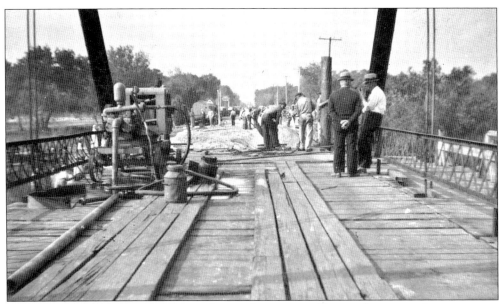

Workers repair the bridge after the truck's accident as two older gentlemen watch.

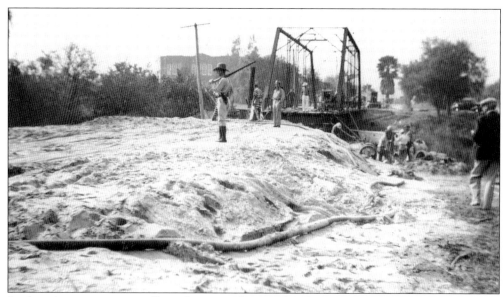

In this photo, correction officers keep watch over the chain gang used to repair the bridge along with state workers. Looking south on South Boulevard, Gulf High School is pictured in the background.

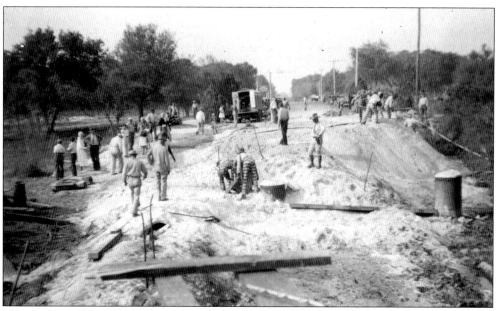

This final scene from 1939 shows the numerous amount of workers that were needed to repair the South Boulevard bridge after its collapse.

Seven

EVENTS

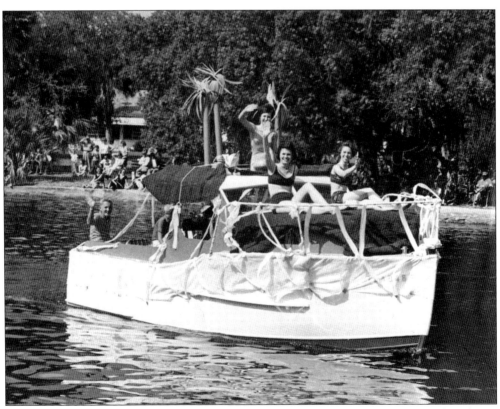

The Boat Parade on the Pithlachascotee River is an annual event that is part of the Chasco Fiesta. Thousands of people line the riverbanks to watch.

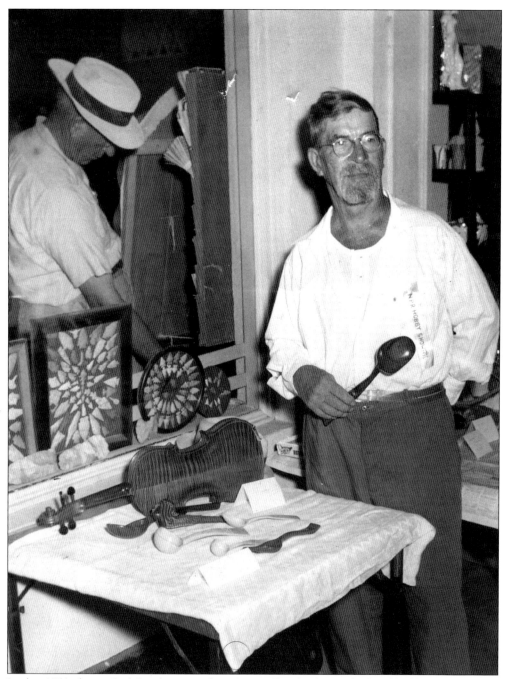

In this 1951 photo, Carl Stenberg stands in front of his display at the local hobby show.

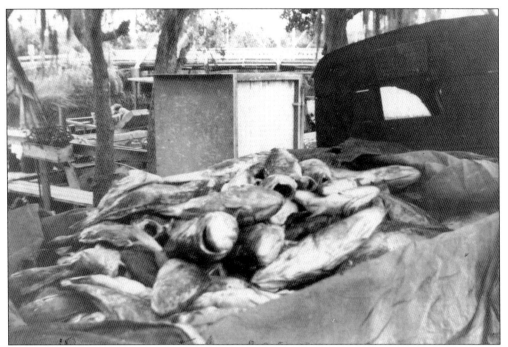

This truck is filled with fish after a good day of fishing in 1948. This photo proves that there are an abundance of fish waiting to be caught in the local rivers, lakes, and Gulf surrounding the New Port Richey area.

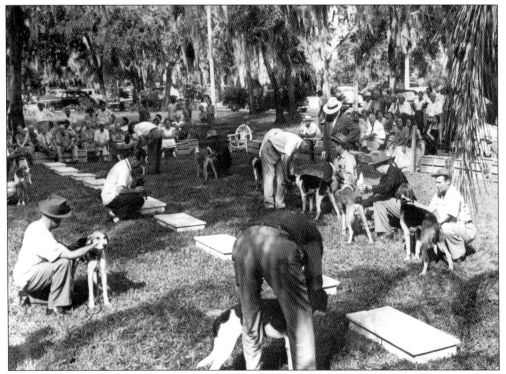

The dog show is underway in Sims Park during the Chasco Fiesta of 1950.

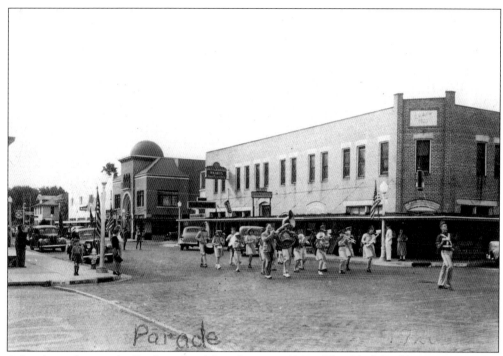

A band marches up the Boulevard at Main Street c. 1940s. The Clark Building is pictured at the southwest corner of Main Street and the Boulevard. Pictured south of the Clark Building is the instantly recognizable, domed Meighan Theater.

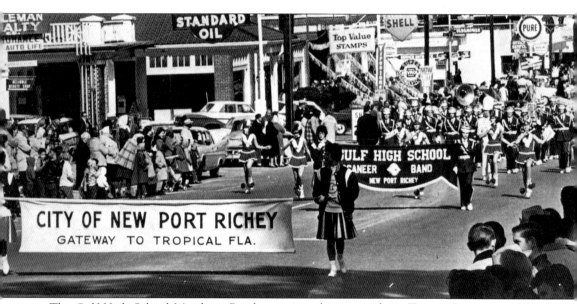

The Gulf High School Marching Band participated in a parade in Tarpon Springs, c. 1964. Gulf High School was first established in 1922, and the band's beginnings date back to 1925 when it was an eight-piece orchestra.

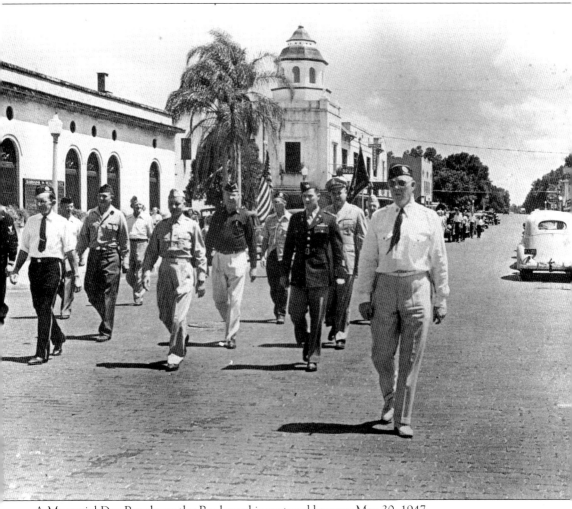

A Memorial Day Parade on the Boulevard is captured here on May 30, 1947.

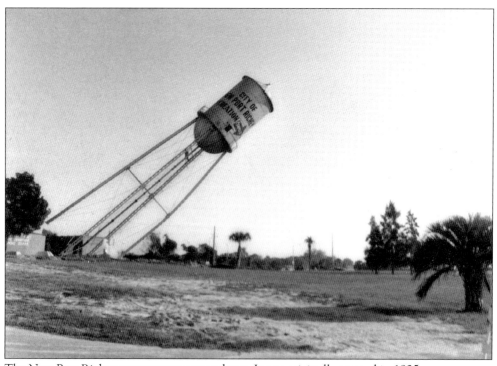

The New Port Richey water tower comes down. It was originally erected in 1925.

This 9/11 ceremony took place at the band shell in Sims Park on September 11, 2003. Gov. Jeb Bush is standing at the podium with the Richey Concert Band, directed by Henry Fletcher, on stage.

In keeping with the Chasco Fiesta tradition, this modern photo shows a high school marching band on the Circle around Orange Lake along Sims Park in 2003.

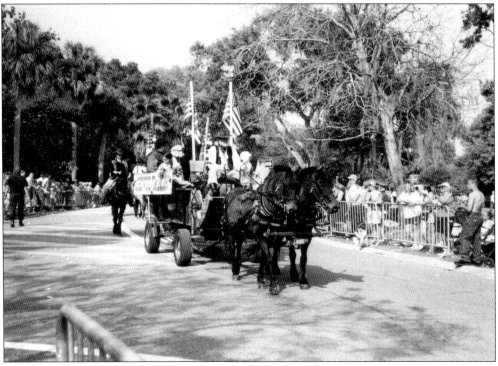

A horse-drawn wagon travels around the lake in the Chasco Fiesta Parade. Parades have been a familiar site in New Port Richey since 1922.

A Native American woman dances at the Native American Festival during the Chasco Fiesta festivities in Sims Park along the Pithlachascotee River.

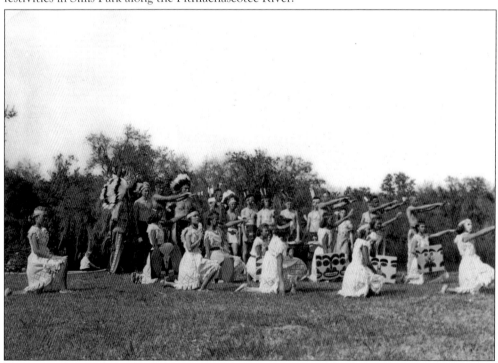

Pictured here are local residents dressed in Native American costumes in a ceremony for the Chasco Fiesta, c. 1950s.

Pictured here in 1947 are King Pithla (Bob Jackson) and Queen Chasco (Bob's sister Mildred). Naming a king and queen is an annual event at the Chasco Fiesta in honor of the myth written in 1922 by New Port Richey's first postmaster, Gerben M. DeVries. According to the legend, "Queen Chasco, through whose domain flows the palm-hidden river, reflects on its placid bosom all the beauties of nature." King Pithla is the ruler of the queen's city and guardian of the queen's seal.

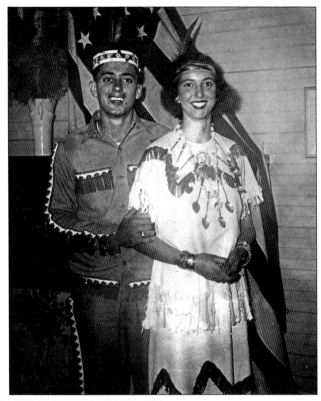

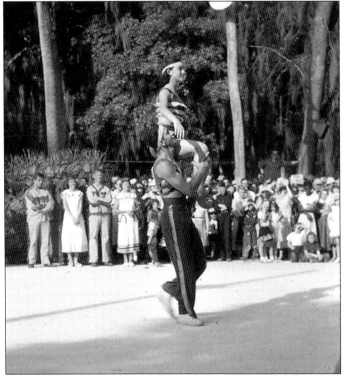

In this photo from 1952, two young people perform for the crowd at the annual Chasco Fiesta. The performers as well as the spectators wore Native Americans costumes during the celebration.

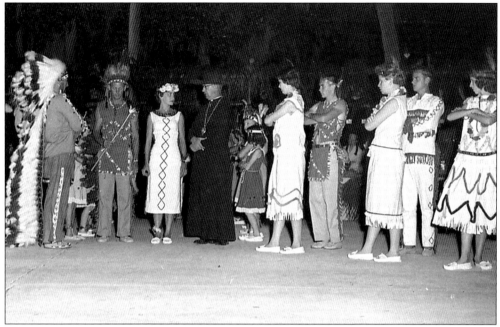

The legend of Chasco was performed annually in Sims Park. Local residents would portray Mucoshee, chieftain of the Calusas, and Pithla, who marries Chasco and becomes king. Also portrayed is Chasco, who becomes queen, and Padre Luis, the Spanish priest.

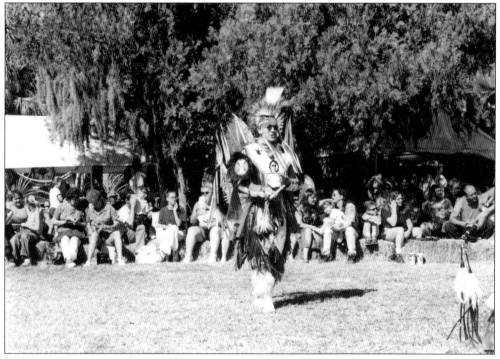

A Native American performs within the tribal circle at Sims Park during the Chasco Fiesta. In recent years, Native Americans have been coming to the annual event from throughout the United States, Canada, and Central and South America.

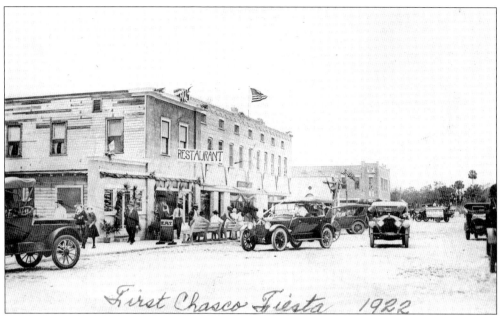

This scene on Main Street was the first Chasco Fiesta Parade in 1922.

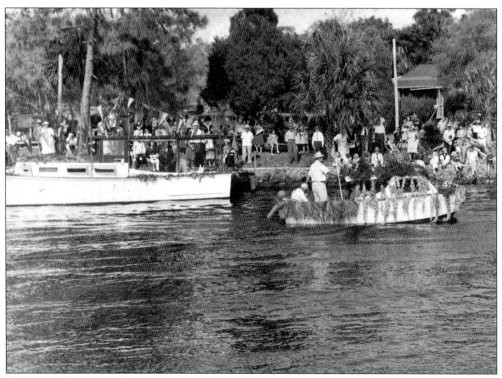

This scene from 1950 shows a decorated boat traveling on the Pithlachascotee River during the Chasco Fiesta Boat Parade.

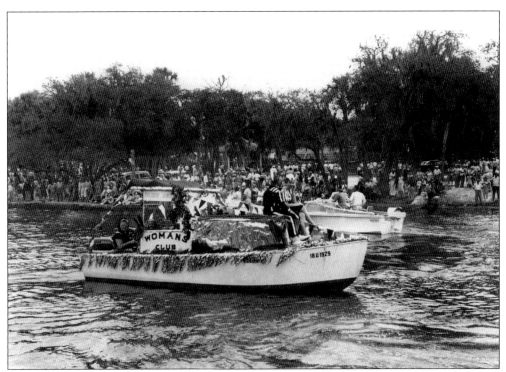

Pictured here is a boat representing the New Port Richey Woman's Club in the 1961 Chasco Fiesta Boat Parade.

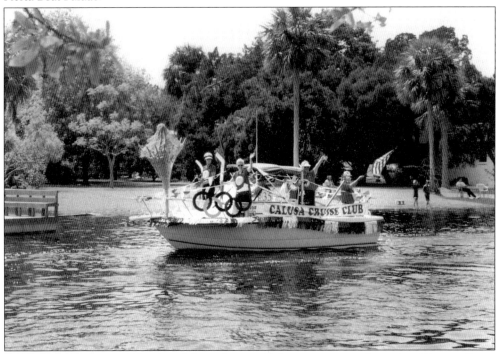

In this photo from 1998, the Calusa Cruise Club is represented in the Chasco Fiesta Boat Parade.

Eight
EXTRAS

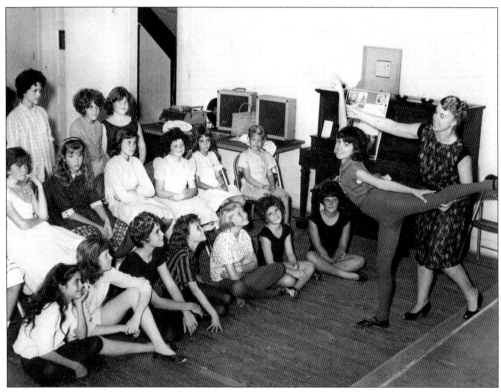

In this photograph, a young girl demonstrates her technique to the dance class c. 1950s.

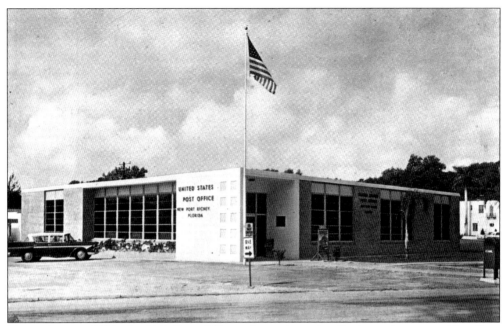

Shown here in 1959, the U.S. Post Office is located on the Circle in downtown New Port Richey. Today, the First Baptist Church is located at this site, and the U.S. Post Office was moved farther east to a new location on Main Street.

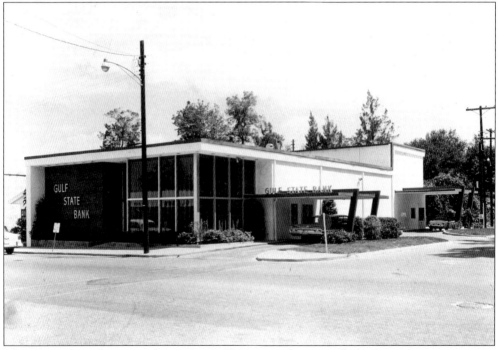

This photo from the 1960s shows the Gulf State Bank, originally built on this site in 1955. Before moving to this location, Gulf State Bank used the same building that formerly housed the First State Bank at the corner of Main Street and the Boulevard. In 1962, Gulf State Bank became First National Bank.

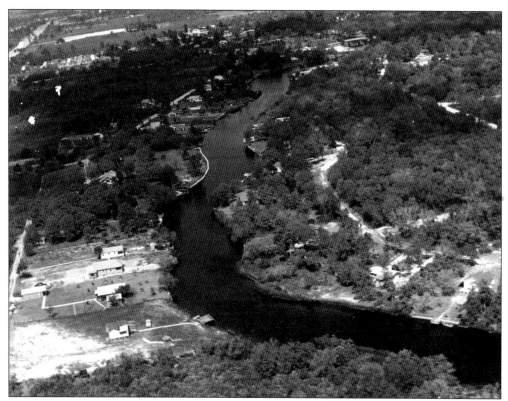

This 1950s aerial view shows the Pithlachascotee River winding its way through New Port Richey.

The Richey Plaza Shopping Center is located on U.S. Highway 19.

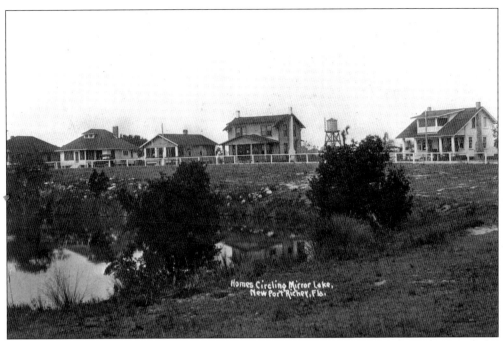

Some of the earlier homes built around Mirror Lake, now Orange Lake, are shown here with the New Port Richey water tower in background, c. 1925.

This tranquil scene shows a man fishing on the Pithlachascotee River in Sims Park north of the Main Street Bridge.

Pictured here is a wind machine used in orange grove irrigation. Pasco County was a major citrus producer, and water was and still is a precious resource.

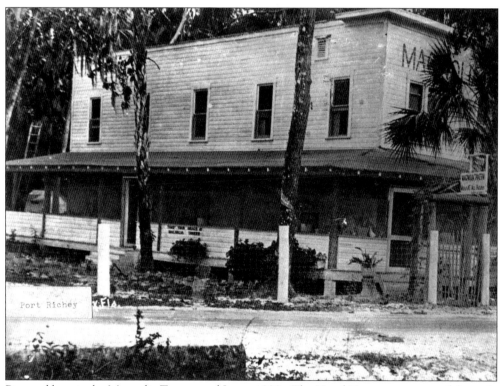

Pictured here is the Magnolia Tavern and Inn c. 1920s. The Hotel Newport was one of the early hotels built on the Boulevard in 1914 by A.J. Pauels and Mike Broersma. In 1923, it was sold to Chauncey York and became known as the Magnolia. This building no longer stands.

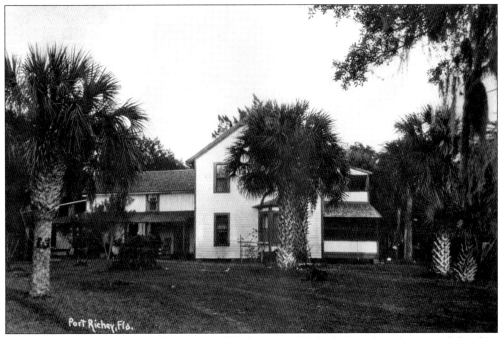

This home was once occupied by James Washington Clark, believed to be one of the first permanent settlers in the area. This structure was built in 1889 and has been modified many times. The Clark family operated this building as a boarding house, which was renamed the Bay Lea Inn when LeRoy and Mary Jane Bailey bought it in 1917. The Baileys expanded the facilities and opened a hotel and restaurant.

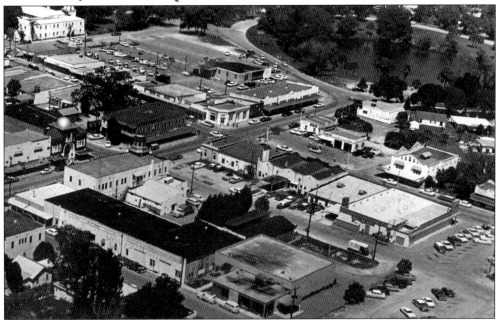

This 1950 aerial view of the downtown business district shows Orange Lake at the north end. As you travel north on the Boulevard, on the left is the domed Meighan Theater and across the street is the Pasco Building with its octagonal cupola.

Pictured here are the recipients of the grand prize awards at the Chasco Fiesta in 1962.

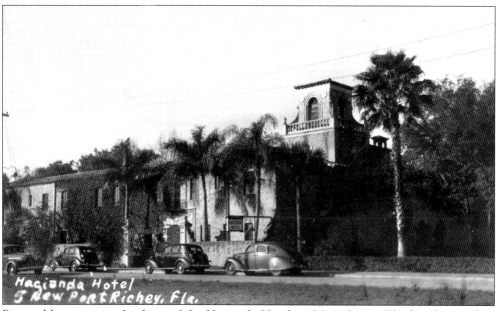

Pictured here is an early photo of the Hacienda Hotel on Main Street. The hotel opened its doors for business on February 4, 1927.

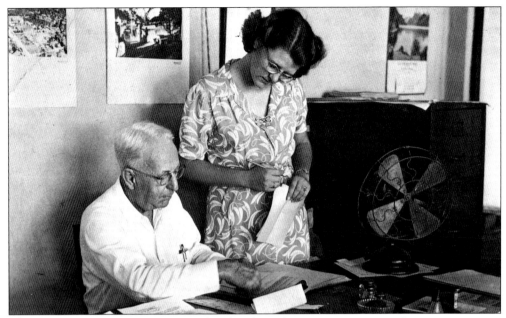

This photo shows a day of work at the chamber of commerce, a group that sponsors many community events.

This 1960s picture shows Burt's Television Store. When television first came to New Port Richey, the local barber shop would keep a television on in the window every night. The sidewalk benches were usually crowded with curious people.

Pictured here is Fred Lasey at a 1951 hobby show.

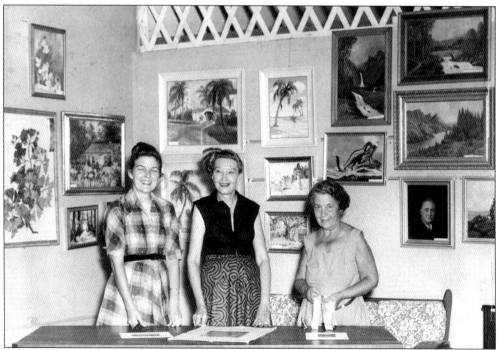

These ladies attend the New Port Richey Festival of Art, held on April 30, 1952.

A photo labeled "Chief Silver Tongue" shows a local resident dressed in a Native American costume at the annual Chasco Fiesta Celebration.

BIBLIOGRAPHY

Ash, Pauline Stevenson. *Florida Cracker Days in West Pasco County 1830–1982*. New Port Richey: Pauline Stevenson Ash, 1985.

Avery, Elroy M., ed. *The Genesis of New Port Richey*. New Port Richey: Avery Library and Historical Society, 1924.

Bellwood, Ralph. *Tales of West Pasco*. New Port Richey: A.J. Makovec Printing, 1962.

DeVries, Gerben M. *Chasco, Queen of the Calusas*. New Port Richey: New Port Richey Press, 1922.

Dill, Glen. *The Suncoast Past*. New Port Richey: Tri-Arts Studio, 1983.

Hendley, J.A. *History of Pasco County Florida*. Dade City: J.A. Hendley, 1943.

Horgan, James J., Alice F. Hall and Edward J. Herrmann. *The Historic Places of Pasco County*. Dade City: Pasco County Historical Preservation Committee, 1992.

West Pasco Historical Society, ed. *West Pasco's Heritage*. New Port Richey: Lisa Printing, 1974.

Strode, Kathleen. "Now and Then in New Port Richey." New Port Richey: West Pasco Historical Society, 1995.